IMAGES
of America

LEXINGTON

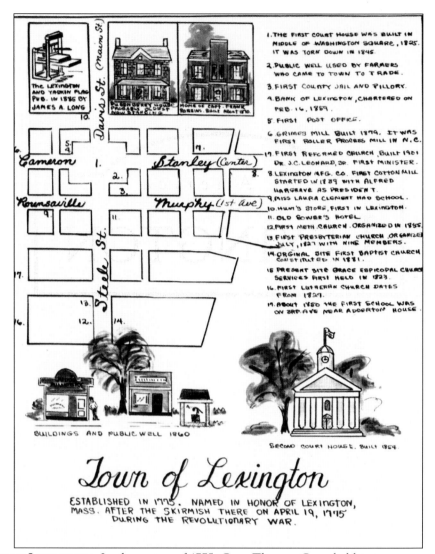

1. THE FIRST COURT HOUSE WAS BUILT IN MIDDLE OF WASHINGTON SQUARE, 1825. IT WAS TORN DOWN IN 1845.
2. PUBLIC WELL USED BY FARMERS WHO CAME TO TOWN TO TRADE.
3. FIRST COUNTY JAIL AND PILLORY.
4. BANK OF LEXINGTON, CHARTERED ON FEB. 16, 1859.
5. FIRST POST OFFICE.
6. GRIMES MILL BUILT 1879. IT WAS FIRST ROLLER PROCESS MILL IN N.C.
7. FIRST REFORMED CHURCH, BUILT 1901 DR. J.C. LEONARD, SR. FIRST MINISTER.
8. LEXINGTON MFG. CO. FIRST COTTON MILL STARTED IN 1839 WITH ALFRED HARGRAVE AS PRESIDENT.
9. MISS LAURA CLEMENT HAD SCHOOL.
10. HUM'S STORE, FIRST IN LEXINGTON.
11. OLD BOWER'S HOTEL
12. FIRST METH. CHURCH. ORGANIZED IN 1855.
13. FIRST PRESBYTERIAN CHURCH ORGANIZED JULY, 1827 WITH NINE MEMBERS.
14. ORIGINAL SITE FIRST BAPTIST CHURCH CONSTITUTED IN 1881.
15. PRESENT SITE GRACE EPISCOPAL CHURCH SERVICES FIRST HELD IN 1823.
16. FIRST LUTHERAN CHURCH DATES FROM 1827.
17. ABOUT 1850 THE FIRST SCHOOL WAS ON 3RD AVE NEAR ADDERTON HOUSE.

BUILDINGS AND PUBLIC WELL 1860

SECOND COURT HOUSE, BUILT 1854.

Town of Lexington

ESTABLISHED IN 1775. NAMED IN HONOR OF LEXINGTON, MASS. AFTER THE SKIRMISH THERE ON APRIL 19, 1775 DURING THE REVOLUTIONARY WAR.

TOWN OF LEXINGTON. In the spring of 1775, Gen. Thomas Gage led his troops across the Charles River in Boston toward the town of Concord, where they believed patriots were storing ammunition and weapons. The direction they were heading passed through the small town of Lexington, Massachusetts. However, before the troops could reach the town, Paul Revere alerted the townspeople. The Lexington minutemen took up arms, and seven of them died that night. A rider quickly spread the news to the south, and a week after the skirmish, the news reached a small North Carolina town. The people of this town were opposed to the high and unreasonable taxes the British were levying on them and upon hearing the news of the resistance named their town Lexington. A marker in Lexington, Massachusetts, honoring the seven men who died in the battle states: "Sword of British Tyrrany [sic] and Oppression April 19, 1775. The dye was cast, the blood of these martyrs and the cause of God and their country was the cement of the Union of these states." (Courtesy of Katherine Skipper.)

ON THE COVER. The children on the merry-go-round, from left to the right, are Jesse "Bill" Hargrave Wright, Mary Gordon Holland, Bobby Green Holton, Virginia Olive Hartzog, Betsy Moffit Goodson, Charles Hatney, Virginia Homes Brinkley, Betsy Mountcastle, and Carol Dorsett.

IMAGES
of America

LEXINGTON

Bo Bennett

ARCADIA
PUBLISHING

Copyright © 2006 by Bo Bennett
ISBN 0-7385-4260-1

Published by Arcadia Publishing
Charleston SC, Chicago IL, Portsmouth NH, San Francisco CA

Printed in the United States of America

Library of Congress Catalog Card Number: 2006920119

For all general information contact Arcadia Publishing at:
Telephone 843-853-2070
Fax 843-853-0044
E-mail sales@arcadiapublishing.com
For customer service and orders:
Toll-Free 1-888-313-2665

Visit us on the Internet at www.arcadiapublishing.com

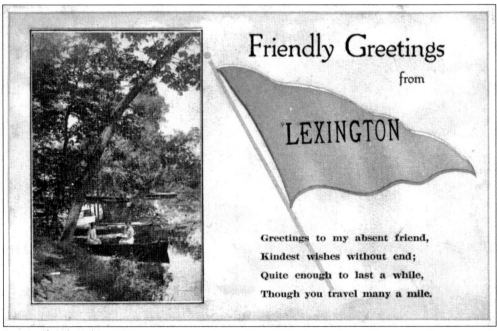

FRIENDLY GREETINGS. "Greetings to my absent friend, Kindest wishes without end; Quite enough to last a while, Though you travel many a mile." The serenity of the postcard and its message would have any traveler longing for the peacefulness and beauty of the town of Lexington. (Courtesy of S. C. View.)

CONTENTS

KATHERINE SKIPPER. A well-known Lexington artist, Katherine played a major role in creating the Arts Council for Davidson County and the Davidson County Art Gallery (now called Arts United and the Arts Center). She is also a charter member of the Genealogical Society of Davidson County and is interested in local and family research. She wrote *Celebration: 100 Years in the Life of First Reformed United Church.* She, along with others, has been instrumental in documenting and preserving Lexington's history. (Courtesy of Katherine Skipper.)

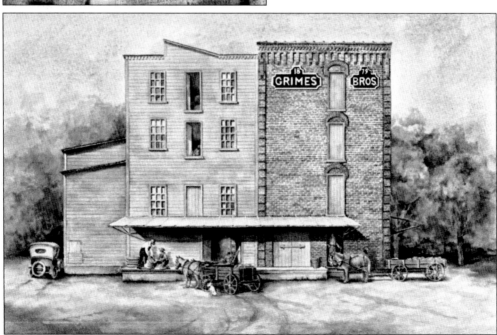

GRIMES BROTHERS. The Grimes Mill, a four-story brick building on the corner of West Center Street and North State Street, was the first roller mill in North Carolina, built c. 1885. The mill produced 75 barrels of flour per day. At one point, Grimes became Security Bank and Trust Company. Today it stands as a historic site. (Courtesy of Katherine Skipper.)

INTRODUCTION

Many names in Lexington can be traced back to their German, Dutch, Scotch-Irish, and English roots. These brave immigrants came to the area and found a climate that was good for crops as well as religious freedom. The forefathers of Lexington were instrumental in the foundation and creation of beautiful homes, schools, and churches.

Prior to the 20th century, Lexington became a trading point and, slowly through the years, a distribution place for two major railroads. The town became known for, among other things, its cotton goods, furniture, monuments, building supplies, mirrors, wagons, and, of course, its famous barbeque. The citizens of the town were religious and law abiding. They fought and made sacrifices through the years for their freedoms. The monuments in Court Square tell of the brave souls who sacrificed their lives so their descendants would have a better future.

Photographs in this volume will let the reader witness the many faces and places that helped Lexington become what it is today. The reader will witness the growth and the transformation of the town from dirt roads and a village well to electricity, paved roads, and running water. These images will also allow the reader to glimpse the homes and churches, the workers who keep industry alive, and the townspeople as they relaxed and had fun.

Today the small-town politeness and hospitality is still evident, even though the town has grown from 1,440 in 1900 to the present-day population of 20,385. Even with this growth, a stroll down Main Street can bring one back to the ambiance of yesteryear by stopping into Main Street Deli for a quick bite and sweet tea, a Southern tradition, and then going next door to the Candy Factory, which offers confectionary treats from the early years. Whether you're a local and call Lexington home or a visitor in town for the Barbeque Festival, Lexington will captivate and inspire your heart. Many of the stories of how Lexington became the town it is today are here within these pages.

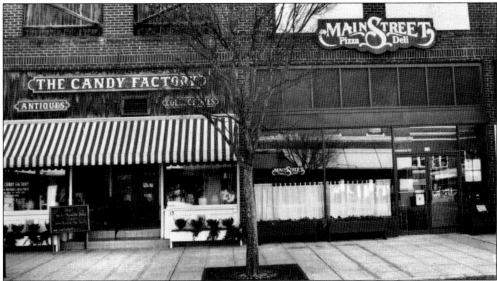

This is a photograph of Main Street Deli and the Candy Factory.

ACKNOWLEDGMENTS

I would like to thank everyone who helped me with this book; I appreciate the time, phone calls, e-mails, interviews, and photographs that have been generously provided to me. If I have omitted any name accidentally, please know that I thank you, too.

I am especially grateful to Pam Daniels, Gail Harrison, and Catherine Hoffmann at the Davidson County Historical Museum for making the museum's resources available for this project. I also appreciate the help from Evelyn Smith at the Davidson County Public Library, along with the people who opened their homes and shared their photographs and fond memories of Lexington with me: Walter Brinkley, Katherine Skipper, Joe Dillard, Vance and Joy Walser, Merle and Jerry Hodges, Jimmie Jean Hunt, Jesse "Bill" Hargrave Wright, Gene Fritts, and Layne McCarn at the Bob Timberlake Gallery.

Additionally I would like to thank the populace of Lexington who graciously took their time to speak with me and share their resources: Connie Motlow, Ann Lanier Easter, David Inabinett, J. J. Fashimpaur, Brenda Leonard, Lisa Coons, Jim Nance, Leigh Foster, Jackie Hearn, Lou G. Adkins, Marty Richardson Tribal Planner, Haliwa-Saponi Indian Tribe, Robert Chapman, Occaneechi State Park, Kim Cumber, Raleigh National Archives, Walter Turner at the Transportation Museum in Spencer, Rev. Calvin Crump, Sarah Leverett, Linda Rankin, Marquita Chapman Buchanan, Gertrude Mabry, Rev. Paul Milton, Denny Whalen, Carl McKnight, R. V. "Bud" Ward Jr., Ed Ward, Paul McCrary, John Blackfeather, Linda Little Tysinger, Velma J. Little, Christy Jarvis of Café 35, and Stephen W. Coles.

A special thank you goes to my sister, Valerie Rovin, for all her support during this project.

Lastly many thanks to my husband, Tim, and son, Stephen, for their understanding and patience while I was writing this book.

One

EMERGENCE OF A
ROBUST TOWN

SAPONI INDIANS. The Dudley-Lynch family shown here is part of the Haliwa-Saponi tribe. The Saponis were the first inhabitants of the land now known as Lexington, North Carolina. They, along with related Siouans, Tutelos, Occaneechis, and others are thought to have originated in the Ohio River Valley. The Siouans split into several groups, many going north and west, others migrating south into what is now North Carolina and Virginia. They called themselves *Yesah* (the People) and various derivations of that word. They were fearsome warriors and specialized traders. Traditionally the Saponis were woodland people subsisting through hunting, gathering, fishing, and farming. Only a few dozen words have been recorded from the Saponi language, one of which is *Junkatapurse*, which means "horse head." When the colonists started arriving, bringing war and illness, many Saponis left and went west to join other bands that were their allies. (Courtesy of Marty Richardson, Haliwa-Saponi tribe.)

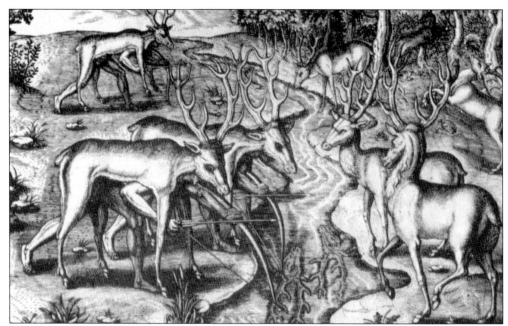

HUNTING DEER. The Native Americans were keen hunters. The braves shown here on the left side of the river were carefully disguised under deer pelts. They would try and mix with feeding deer so they would be able to bring down their prey at close range. The meat was used to make stew and mixed with vegetables and nuts. (Courtesy of the North Carolina State Department of Archives.)

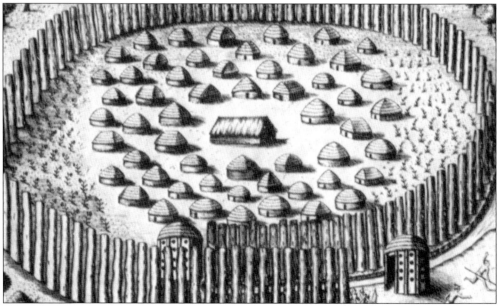

VILLAGE. Fortified villages were built by Native Americans who came to this area in 1550. These Native Americans, known as "Invaders," drove the original Piedmont Indians north. The villages they constructed were surrounded by pine poles and also equipped with watchtowers. About 100 years later, the original Siouan tribes returned to the area and reclaimed their land. (Courtesy of the North Carolina State Department of Archives.)

PERCY RICHARDS. Vice-Chief Percy Richardson's photograph was taken in the late 1960s or early 1970s. The ceremonial dress shown here is not traditional regalia per se, but rather a plains-style outfit, which is what most of the chiefs began wearing in the 1960s. (Courtesy of Marty Richardson Haliwa-Saponi Tribe.)

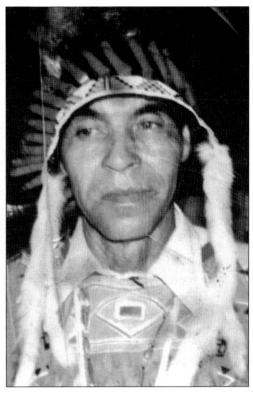

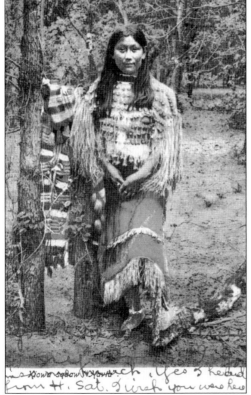

NATIVE AMERICAN WOMAN. This 1907 postcard was sent from a Lexington admirer to Searles Owen. The card shows a Native American woman of unknown origin. The women in a tribe were traditionally responsible for preparing the food and taking care of the children. They also made pottery from crushed quartz mixed with clay. They would make coils from the clay and shape them into pots. Fabric would be placed on the outside of the wet pot to imprint a design into the clay. These pots were used for cooking stews and storing corn, beans, and water. (Courtesy of the Davidson County Historical Museum.)

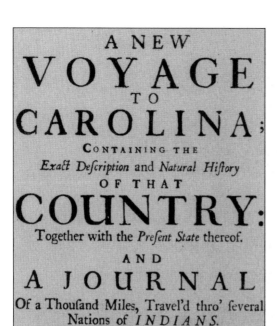

A NEW VOYAGE TO CAROLINA;

CONTAINING THE

Exact Defcription and Natural Hiftory

OF THAT

COUNTRY:

Together with the Prefent State thereof.

AND

A JOURNAL

Of a Thoufand Miles, Travel'd thro' feveral Nations of *INDIANS*.

Giving a particular Account of their Cuftoms, Manners, &c.

By JOHN LAWSON, Gent. Surveyor-General of *North-Carolina*.

JOHN LAWSON. Originally from London, Lawson was appointed surveyor-general of North Carolina, arriving in South Carolina by sea in the early 18th century. During his time in North Carolina, he documented the populations of natives and their cultures. He surveyed the lay of the land and gave us the earliest detailed descriptions of the animal and plant life in the area. Unfortunately Lawson was put to death by the Tuscarora Indians after insulting one of the tribal members in September 1711. (Courtesy of Katherine Skipper.)

TWENTY-FIVE ACRES. Once it was determined that Lexington was going to be the county seat, gentlemen known as the founding fathers of Lexington—Alexander Caldcleugh, Jesse Hargrave, and Benjamin Rounsaville—sold 25 acres of land to the county. This land was used for the courthouse, jail, and other buildings needed for the growing town. The men only received 50¢ a piece and the rights to the timber on the property. (Courtesy of North Carolina State Archives.)

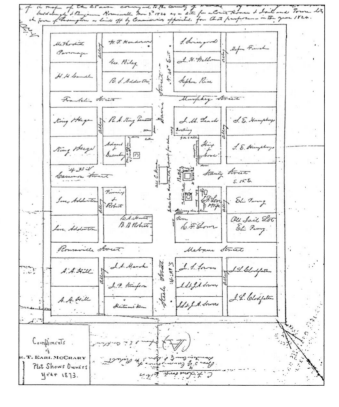

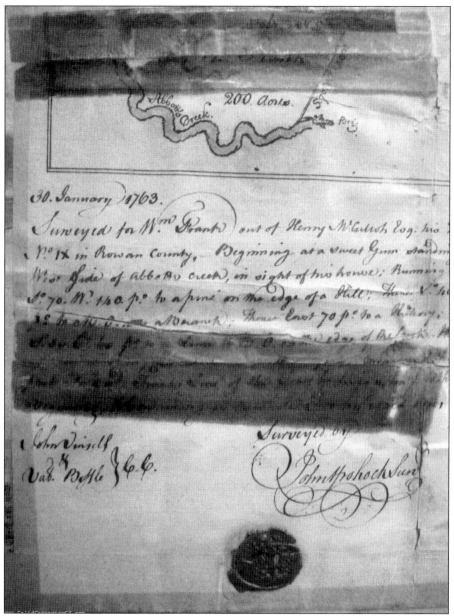

LAND GRANT, 1763. This is the original land grant from King George II to Henry McCulloch. McCulloch acted as an agent for the king with the authority to give out land grants. It states: "Witnesseth that whereas His Most Excellent Majesty King George the Second, the sundry Grants dated the Third of March AD 1745 Gave and Granted to the said Henry Mcculloch 8 tracts of land in North Carolina containing 12,500 acres each lying upon the Yadkin or Pee Dee River and branches thereof and making together One Hundred Thousand Acres of land commonly called or known by the name or the Tract Number 9 of all right and privileges of hunting, hawking and Fithing and Fowling, with all the woods, waters and rivers, with all profits, Commodities and hereditaments to the same belonging or appertaining to him the said Henry McCulloch, his Heirs and Assigns forever and as full and ample Manner as of the Manor of East-Greenwich." (Courtesy of Jimmie Jean Hunt.)

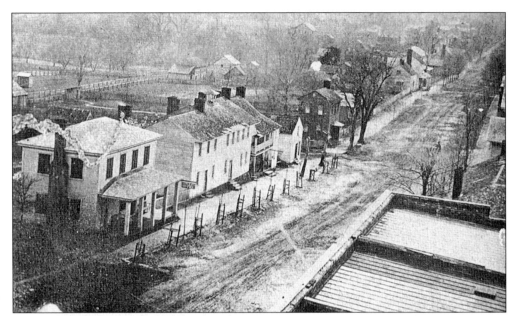

BIRD'S-EYE VIEW. This peaceful view of Main Street looking south was taken from the top of the courthouse in the early 20th century. The big house on the left is believed to be Ms. Earnhart's boardinghouse. Hitching posts can be seen in front of the houses. Most townspeople had smokehouses, pigpens, horses, and vegetable gardens. Residents had to be sure to keep the gardens and wells above the runoff from animals and outhouses for fear of a typhoid outbreak. (Courtesy of Davidson County Historical Museum.)

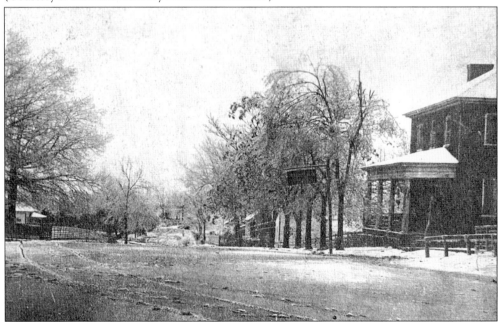

RESIDENTIAL NEIGHBORHOOD. The streets were bare on this winter's day. The house on the right in the photograph has a sign hanging in front of it, which indicates that it might be a boardinghouse. Fences line either side of the packed mud road. (Courtesy of Davidson County Historical Museum.)

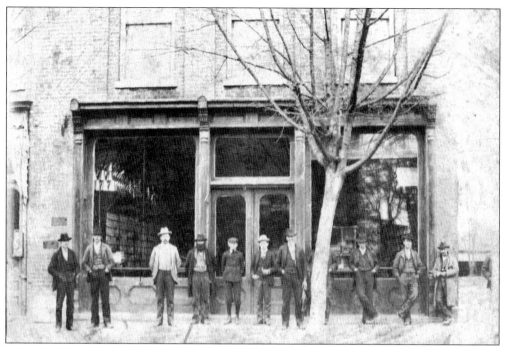

CLEMENTS AND HARGRAVE DRY GOODS STORE. The unidentified men in this photograph are standing in front of the Clements and Hargrave Dry Goods Store. The men worked for Advanced Wagon Works. (Courtesy of Davidson County Historical Museum.)

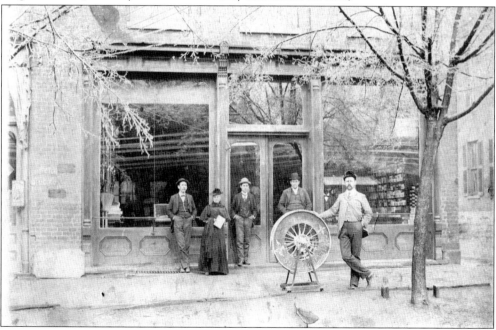

PHOTO OP. The owners of the Clement and Hargrave Dry Goods Store are seen posing in this photograph. From left to right are J. L. Clement, Florence Hanes, W. G. Hinkle, R. S. Hargrave, and C. C. Hargrave. All the gentlemen are wearing hats, which was common in the 1920s. (Courtesy of Jesse Hargrave Wright.)

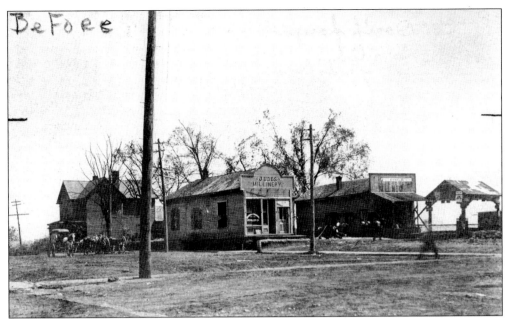

JUDDS MILLINERY. This is one of the earliest photographs of Lexington on the square in the early 20th century. The home behind the millinery was the residence of G. H. Greer. Perhaps the people in the carriage were headed for the millinery to purchase a hat, or maybe they were headed to the town well (far right) to get some water. (Courtesy of the Davidson County Historical Museum.)

SAM HARGRAVE LAW OFFICE. Sam Hargrave was the son of Jesse Hargrave, who was born in 1777 and is remembered as one of the founding fathers of Lexington. The Hargraves emigrated from England to Virginia in 1635 and came upon good fortune in Lexington. Sam Hargrave stands in front of his office with perhaps his brother, Alfred. Sam and Alfred served in the North Carolina State Legislature. (Courtesy of Davidson County Historical Museum.)

J. F. WARD COMPANY. This 1907 business block is the first brick building constructed in downtown Lexington. The bricks were made near the City Cemetery. The building was known as the Iron Front Building because of the hardware that J. F. Ward Company and Redwine Hardware sold. Other merchants in the building included a dry goods and furniture store. Today the same storefront is the home to Shotos, the Candy Factory, and Main Street Deli. (Courtesy of Davidson County Historical Museum.)

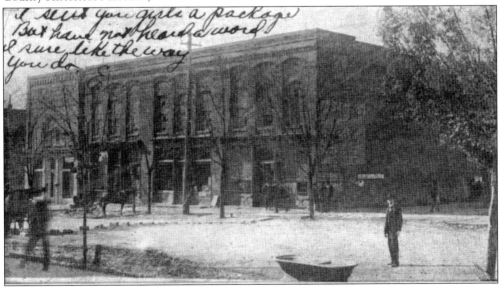

PENNY AND MCCARY BLOCK. Evelyn Smith remembers when a spool of thread cost a nickel at the W. G. Pennery Company. She also remembers accompanying her mother to the store. She ended up wandering away and falling down a flight of steps. Everyone in the store searched for little Evelyn, and they found her in a coal bin. She was black as night when she was rescued. Her relieved mother washed her face and hands, gave her a firm spanking, and marched her home. (Courtesy of the Davidson County Historical Museum.)

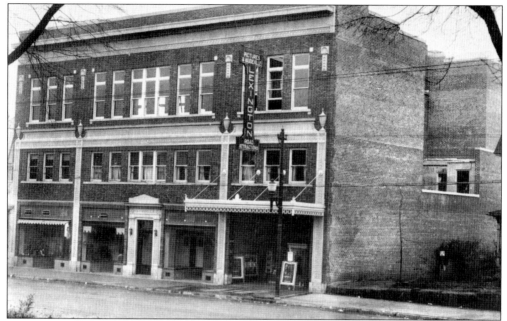

Carolina Apartments. The Carolina Apartments were located on the second floor of this building. On December 5, 1945, the apartments and the theater caught on fire. Damages were estimated at $350,000. The residents of the apartment building scrambled to safety. One woman's husband was coming home from the war the following day, and the only items she was able to save from the apartment were the nightclothes on her back and the sandals on her feet. (Courtesy of Davidson County Historical Museum.)

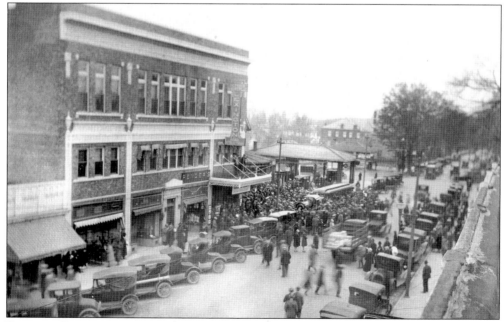

Bustling Downtown. A crowd is gathered outside Lexington Road Attractions. Three boys can be seen standing on the awning of the building looking down at the crowd below. What looks like a railroad car is parked in front of the building. (Courtesy of Edward C. Smith Civic Center.)

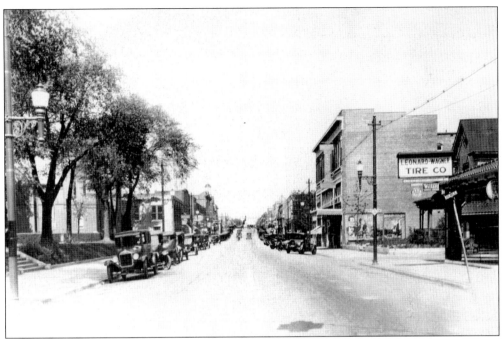

LEONARD-WAGNER TIRE COMPANY. This tire company was located on Main Street and Third Avenue. A boardinghouse was nestled between the tire company and the Lexington Theater. An advertisement for Belks can be seen on the side of the brick building. (Courtesy of Davidson County Historical Museum.)

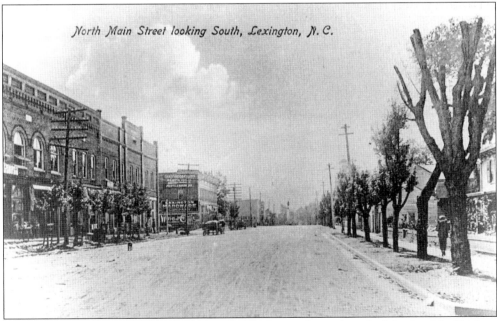

NORTH MAIN STREET, 1916–1917. Lexington Hardware is located on the left side of the block, as well as the Old Thompson Company. A lone dog can be seen in the road. It's a good thing there was not a lot of traffic. The pooch may have been a stray or have come from one of the many homes that lined the right side of the street. (Courtesy of Davidson County Historical Museum.)

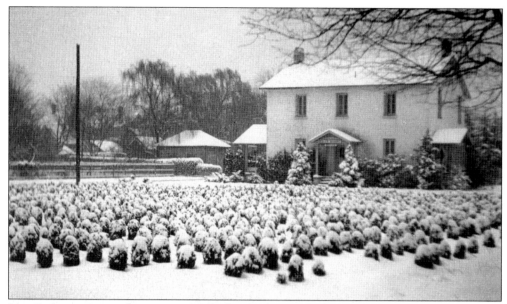

JAIL. Jail was never a place anyone wanted to be, but in the late 19th century, it was a suitable alternative to the public gallows, whipping post, or the pillory. The gallows were constructed and located near the gate to the Lexington City Cemetery, and the whipping post and pillory were located on Washington Square, later named Court Square. This brick building was the county's second jail and is now home to the health food store From the Earth. (Courtesy of Davidson County Historical Museum.)

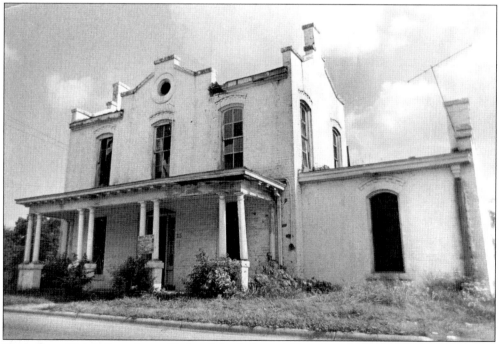

BRICK JAIL. This jail was located behind the Reformed Church on North Salisbury Street. The first brick jailhouse was constructed in the 19th century. The photograph was taken around 1930. (Courtesy of Davidson County Historical Museum.)

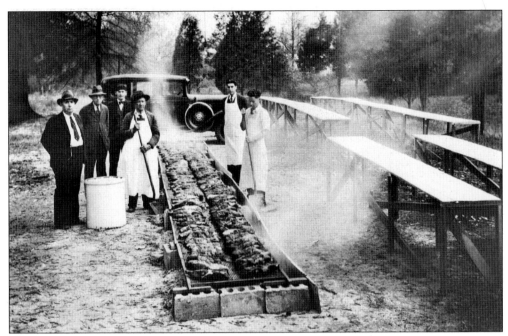

BARBEQUE. Jesse Swicegood, standing at left in the apron, opened a business next to Sid Weaver's barbeque in 1923. Mr. Swicegood is cooking pork shoulders on an open pit off West Third Avenue. A tasty barbeque lunch could be had outside of the courthouse, where it was sold when court was in session. (Courtesy of Davidson County Historical Museum.)

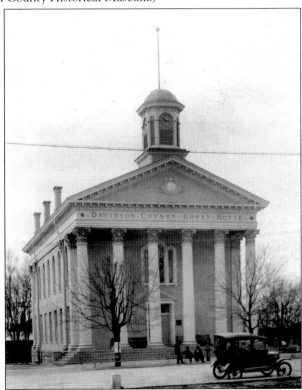

DAVIDSON COUNTY COURTHOUSE. The first courthouse was a two-story brick building completed in 1858. Unfortunately it caught fire in 1865, during the Civil War, and many believed federal troops were to blame. The building was not completely repaired until 1868. The courthouse is of Classical Revival style and has beautiful Corinthian capped columns and granite steps. Note the three chimneys on the top of the building. Today the courthouse is the home of the Davidson County Historical Museum. (Courtesy of Davidson County Historical Museum.)

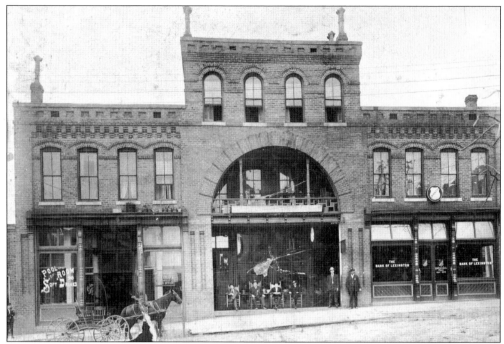

MARCH HOTEL. In the 1880s, March Hotel was owned by Mrs. J. E. March and was a wooden structure. The hotel burned down in 1909 and was replaced by a beautiful three-story building, which still stands today. In 1923, Kate Mays started the first county library in one of the rooms. Bob Sink ran the dining room after his café, the Liberty Lunchroom, caught on fire and the kitchen was badly burned. Today the second and third floors of the hotel are no longer in use, and the bottom part of the hotel is occupied by various merchants, including Southern Curiosities restaurant. (Courtesy of Davidson County Historical Museum.)

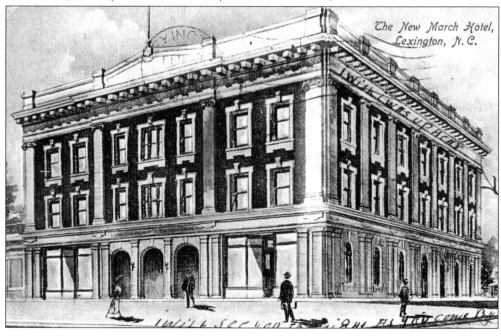

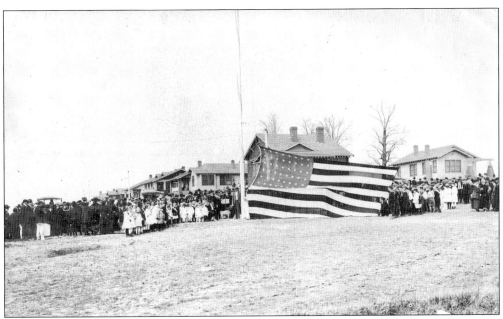

FLAG DAY. The residents of Lexington showed their patriotism as they turned out to watch as an enormous flag was raised in a residential section of town. (Courtesy of Davidson County Historical Museum.)

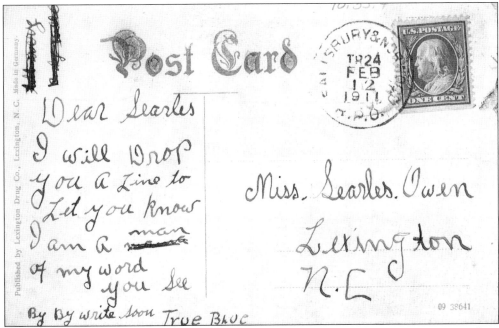

TRUE BLUE. This postcard, dated 1911, was sent to Searles Owens. She is told that her friend is a "man of his word," as he drops her a line like he promised. Wouldn't it be nice if postage stamps only cost 1¢ today! (Courtesy of Davidson County Historical Museum.)

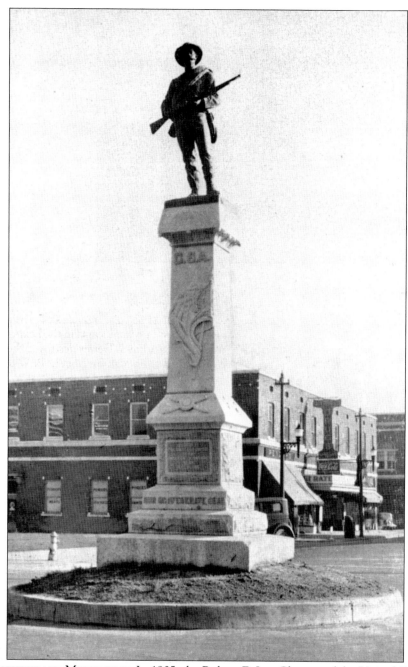

THE CONFEDERATE MONUMENT. In 1905, the Robert E. Lee Chapter of the United Daughters of the Confederacy dedicated this monument, which reads "1861–65. Sleep Sweetly by your humble graves, sleep martyrs of a fallen cause, For Lo a marble column craves the Pilgrims here to Pause." Main and Center Streets was home to this monument for many years. The statue's location seemed to cause many fender benders. Inebriated drivers, traffic accidents, and a large Merry Christmas sign all contributed to the monument being knocked off its pedestal. Finally it was decided to move the statue from the center of Court Square to a safer location. (Courtesy of Davidson County Historical Museum.)

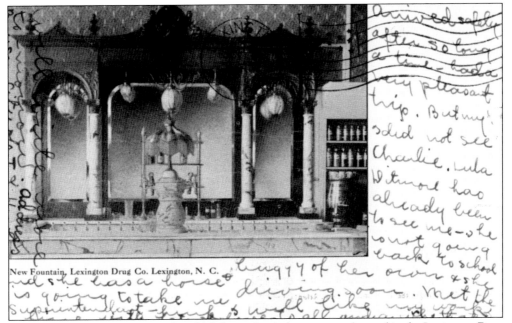

New Fountain, Lexington Drug Co. Lexington, N. C.

LEXINGTON DRUG COMPANY. This old-fashioned soda fountain was located in the Lexington Drug Company. According to Bill Welborn, in 1898, the week Admiral Dewey destroyed the Spanish Fleet in Havana, Bill's father, William F. Welborn, bought the business from L. B. Wheeler. It is located in the building where the Calvin Cunningham law office is today. (Courtesy of Davidson County Historical Museum.)

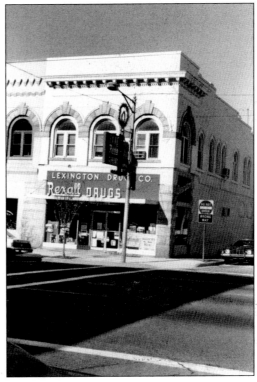

REXALL DRUGS. The front of the Lexington Drug Company is seen here occupying the same space as the old Clement and Hargrave Company. The drugstore offered a family-friendly atmosphere, with an ice-cream parlor with a variety of delectable treats for its patrons. Lexington Drug Company is now located on 405 Center Street and is owned by Connie and Mark Motlow, who still run the old-fashioned soda fountain and offer the same neighborly atmosphere as the prior owners. (Courtesy of Katherine Skipper.)

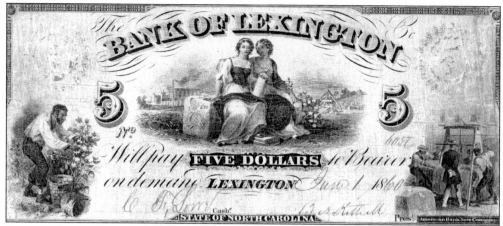

BANK OF LEXINGTON NOTE, 1860. This bank note for the Bank of Lexington was printed just prior to the beginning of the Civil War. In 1860, $5 would fetch five acres of unimproved land in Davidson County. A horse or mule could be purchased for $90, and a pair of oxen was $75. Today the cost of living has increased by $21 for every $1 in 1860. (Courtesy of Davidson County Historical Museum.)

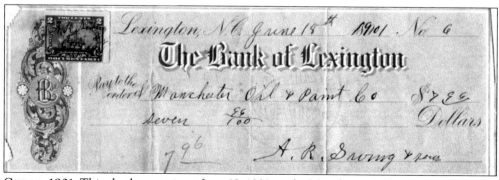

CHECK, 1901. This check was written June 18, 1901, to the Manchester Oil and Paint Company for $7.99. The emblem of the Bank of Lexington and a 2¢ documentary stamp are located in the corner of the check. (Courtesy of Merle and Jerry Hodges.)

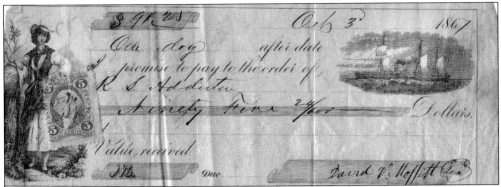

PROMISE TO PAY, 1867. In 1837, and again in 1857, financial crisis caused a loss of confidence in paper money. In 1867, this check was written with a promise to pay R. S. Adderton the amount of $95. Adderton was a successful merchant who, upon hearing that a new railroad from Raleigh to Charlotte would pass through Lexington around 1852, sent his son to the location of the future railroad stop to establish a store. His mercantile business on Main and First Streets was very profitable. (Courtesy of Merle and Jerry Hodges.)

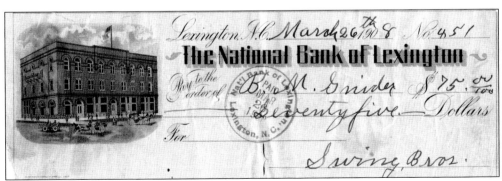

NATIONAL BANK, 1908. The building seen on this check is the development building on the east side of the square. Many offices were located on the top floor. The offices below were occupied at various times by barbershops, a Singer store, and Lummie Joe's School of Dance in 1940s or 1950s. (Courtesy of Merle and Jerry Hodges.)

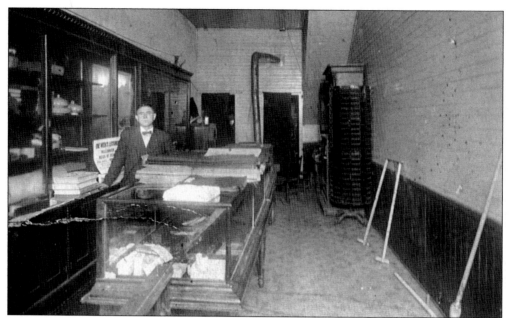

MCCULLOCH. Dr. ("Doc") Webb McCulloch was born October 22, 1908, the son of John Washington McCulloch, and he was married to Effie Adaline Fritts on June 16, 1935. Doc McCulloch was a leader in the business, religious, civic, and political arenas. He is seen here in his store with a sign behind him that tells of a "One Weeks Lecture—Millennium Reign of Peace." He was also a partner in McCulloch's Jewelers in Lexington. (Courtesy of Jimmie Jean Hunt.)

FEBRUARY 1906. This is the calendar Dr. McCulloch had in his jewelry store. The advertisement reads: "Cheap Johns Jewelry Company located on Main Street." The sign states he sells watches, clocks, jewelry, and so forth. (Courtesy of Jimmie Jean Hunt.)

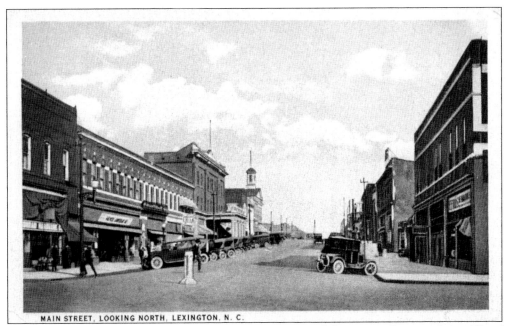

MAIN STREET, LOOKING NORTH, LEXINGTON, N. C.

MAIN STREET LOOKING NORTH. The roads are still dirt, and there is an object in the middle of the road. Perhaps that was placed there as a navigational guide for people to stay on the correct side of the street when they were driving. (Courtesy of S. C. View.)

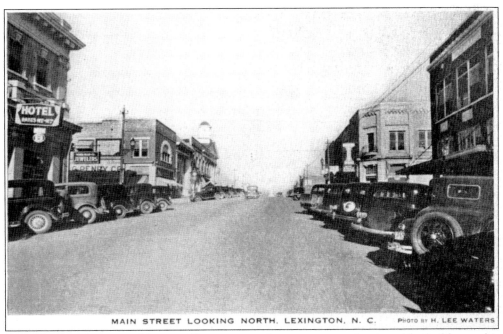

MAIN STREET LOOKING NORTH, LEXINGTON, N. C. PHOTO BY H. LEE WATERS

MAIN STREET LOOKING NORTH. The town is taking on a more developed look. The road is paved, and new businesses line Main Street, including the Bates Motel, a jewelry store, and the Pennery Company, also seen on the bottom of page 17. (Courtesy of the Davidson County Historical Museum.)

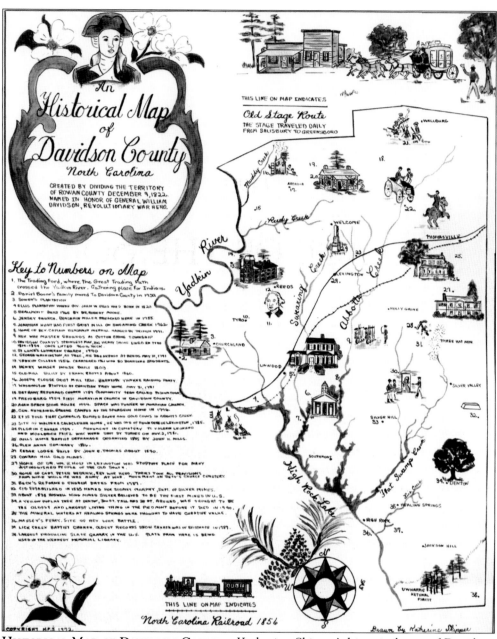

HISTORICAL MAP OF DAVIDSON COUNTY. Katherine Skipper's historical map of Davidson County is an excellent depiction of the townships surrounding Lexington. (Courtesy of Katherine Skipper.)

Two

TILLAGE OF THE SOIL

LITTLE FELLOW. Everyone pitched in on the farm, even tiny Gene Fritts. He learned a lot of good farming techniques from his father, as he went on to be a member of the 4-H Club. The family raised produce, wheat, milk cows, beef cows, hogs, and chickens. (Courtesy of Gene Fritts.)

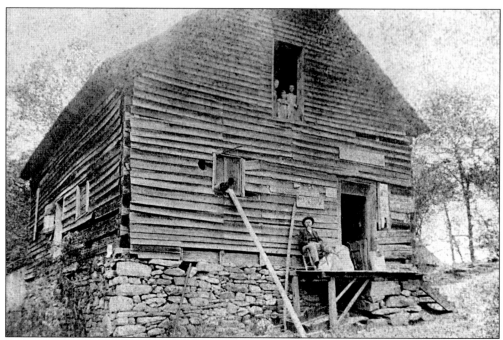

BARN. This photograph, c. 1890, shows children up in the hayloft, with grandpa or dad sitting below. During this period, many of the barns were true to the building designs of the German immigrants, who also brought communal barn-raising to the Americas. Lexington was known for its many farms, which raised a variety of crops including cotton, wheat, Indian corn, rice, oats, tobacco, and sweet potatoes. (Courtesy of Davidson County Historical Museum.)

THE MILK MAID. General farming was very prevalent in Davidson County. Lexington county agents helped the farmers buy and sell commodities through the local co-ops. The county had many different dairy breeds—Jersey, Guersney, and Holsteins. The pure-bred and half-bred Jersey cows produced the richest milk. An increase in production was seen when the cows produced a richer milk, and this led to the Davidson County Creamery being established in Lexington. (Courtesy of the Davidson County Historical Society.)

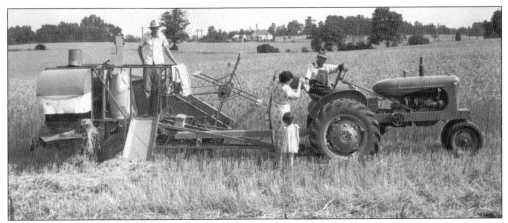

GET-ER-DONE. Jeff Fritts and his son Gene are working diligently harvesting their wheat crop. While his father drove, Gene would stand on the back of the combine filling and tying the sacks before sending them down the shoot to be picked up later. Mae Fritts and her niece, Areta Stokes, bring the men lemonade so they can have a quick refreshment before they continue their work. (Courtesy of Gene Fritts.)

TOBACCO GROWERS. Tobacco has always been a vital crop for North Carolina's economy, and the Tar Heel State has been the number one producer of the golden leaf in the United States. The big leaves seen here were made possible by "topping" the plants in the summer. This is a process in which the flowers are clipped off to allow the plant's growth to be concentrated in the leaves. (Courtesy of Davidson County's Historical Museum.)

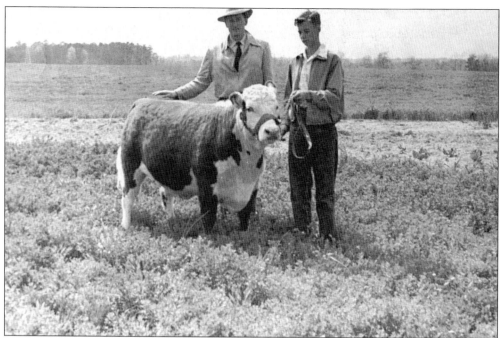

PRIZE HEREFORD STEER. Gene Fritts showed his Hereford steer in a 4-H Club contest and came away winning the grand prize. Gene and the extension agent pose with his prize Hereford. The price for steer brought about $1 a pound, which, according to Gene, "was really good money." Although Gene will always love the farm life, he went on to become the owner of M&L Chrysler Dodge and Jeep in Lexington. (Courtesy of Gene Fritts.)

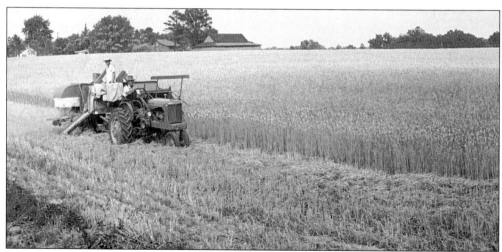

LONG WAY TO GO. Lexington was known for its fertile farms, which are evident in this photograph of wheat. The wheat was often sold locally to one of the milling companies and also used at home to feed the farm animals. With the abundance of farms in the area, the cost of food was considerably less than in places where produce and meat had to be brought in. (Courtesy of Gene Fritts.)

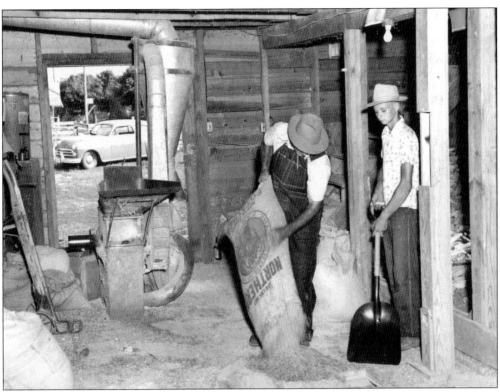

GRINDING GRAIN. Jeff Fritts is seen here with his son Gene in the grinding mill. The grain was stored on the top floor of the building. Interestingly enough, wheat prices in the mid-19th century were $1 a bushel; today they have risen only to $2.50 a bushel, while the cost of production has increased dramatically. (Courtesy of Gene Fritts.)

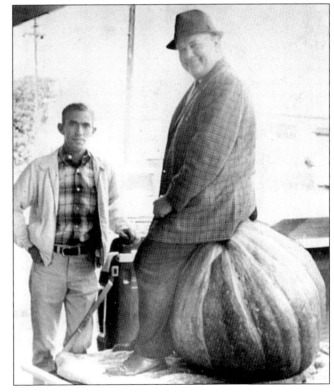

PUMPKIN CONTEST. Bruce Smith had something to be proud of with this 340-pound pumpkin he grew in October 1966. It was so big, he was able to take a seat on his prized possession. (Courtesy of Davidson County Historical Museum.)

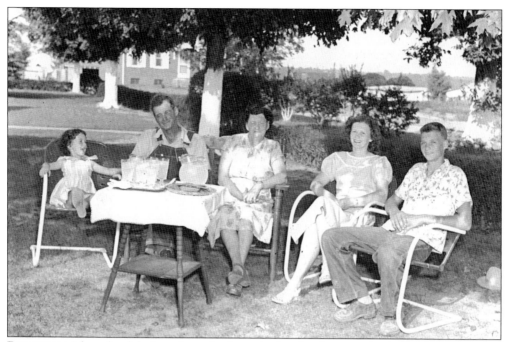

RELAXING. After a hard day's work on the farm, the family relaxes in the shade with a pitcher of lemonade. From left to right are niece Areta Stokes, father Jeff Fritts, mother Mae Fritts, daughter Rachael, and son Gene. (Courtesy of Gene Fritts.)

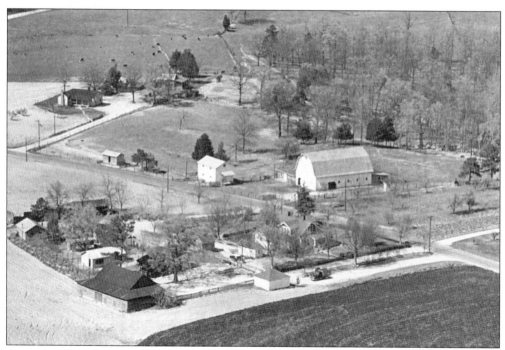

AERIAL OF FRITTS FARM. The Fritts farm consists of 350 acres and includes various outbuildings, barns, a mill house to grind their own feed, and, of course, their family home. (Courtesy of Gene Fritts.)

Three

PLACES TO
HANG YOUR HAT

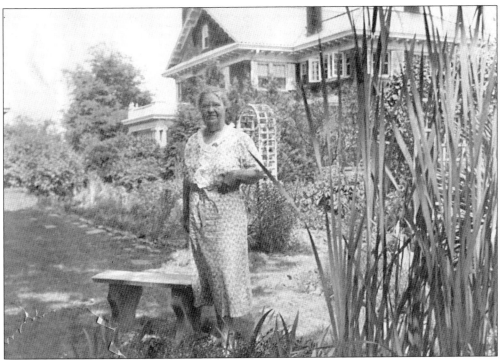

J. V. MOFFITT HOME. Pearlie Moffitt is standing in front of the beautiful Colonial Revival–style residence owned in the early 20th century by Joe Moffitt Sr. of Lexington. Mr. Moffitt ran a grocery store across from the March Hotel. An advertisement for November 6, 1899, read: "Boom Boom Boom But the Biggest Boom of the Season is at Moffitt Bros. A rush all the time, Goods going out by the handful, basketful and wagon load. The best 100 lbs. net of white fish to be had." (Courtesy of Merle and Jerry Hodges.)

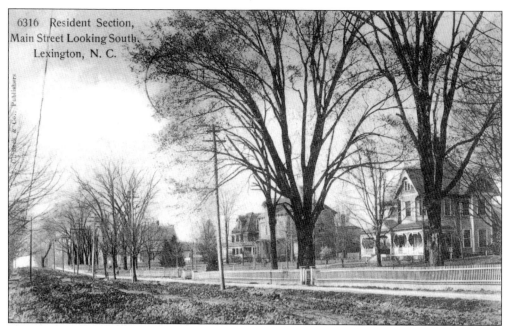

RESIDENTIAL SECTION. Lexington's population in 1900 was 1,440, and in 1920, this number rose to 5,254. Main Street was lined with beautiful homes reflecting the prosperity of the community. Many of the houses have since been removed and have been replaced with businesses. (Courtesy of Davidson County Historical Museum.)

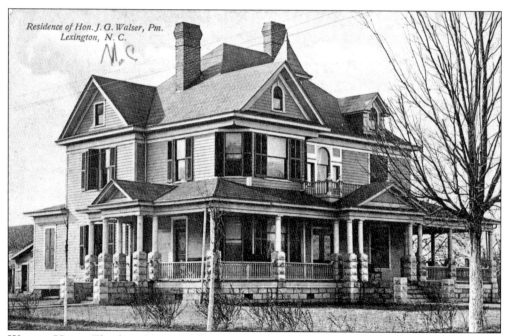

WALSER HOME. This large Victorian home was in the style of Queen Anne. A wing was attached for a library. Schoolteachers lived in the home to teach the Walsers' many children. The kitchen was separated by an enclosed porch, and the property also included a barn and garden. (Courtesy of S. C. View.)

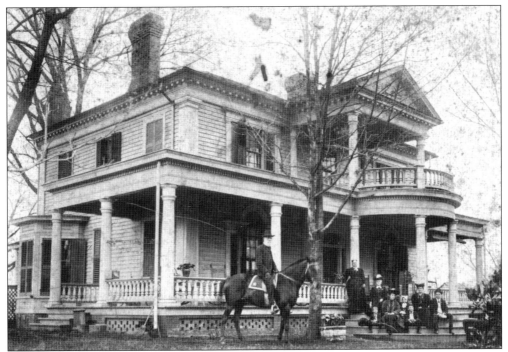

THE HOMESTEAD. This Greek Revival home was built in 1834 by Dr. William Rainey Holt. Dr. Holt's daughter, Fannie Amelia, married Col. Charles A. Hunt (seen here on horseback) in 1869. Colonel Hunt was a founder of the Nokomis and Wennonah Cotton Mills. Dr. Holt was a prominent citizen in the community and was a charter member of the North Carolina Agricultural Society. (Courtesy of Davidson County Historical Museum.)

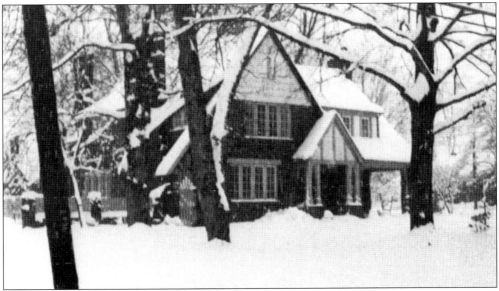

BRITISH VERNACULAR COTTAGE. A cozy fire will keep the original owners, Mr. and Mrs. Lloyd Rainey Hunt, warm in their cottage built in the early 1920s on this winter's day around 1927. Located on South State Street, the design of the house is based on 17th- and 18th-century British vernacular cottages. (Courtesy of Davidson County Historical Museum.)

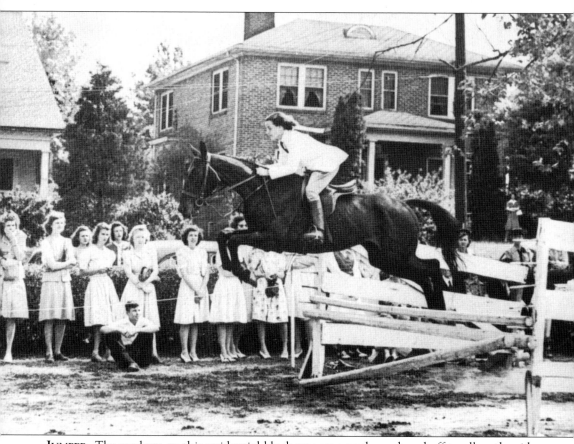

JUMPER. The roadway on this residential block was apparently cordoned off to allow the rider and her horse a place to jump. The women on the far left gasped as the horse and rider leapt through the air in front of the Old Grimes Home Place, located on East Fourth Street. (Courtesy of Edward C. Smith Civic Center.)

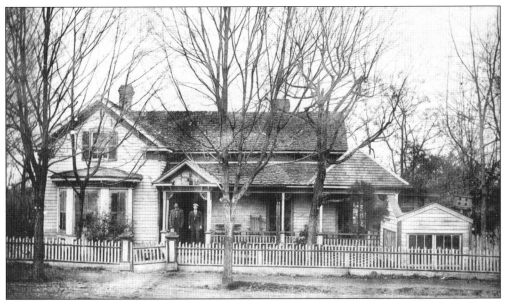

RAYMOND AND CARR WARD. The Wards are seen standing in front of their home. They owned and operated a thriving business called the E. M. Ward Company, seen on page 95. Their house was located across the street from their business, which made it convenient for them to go back and forth to work everyday. In 1935, the house was moved to Salisbury Street. (Courtesy of Edward C. Smith Civic Center.)

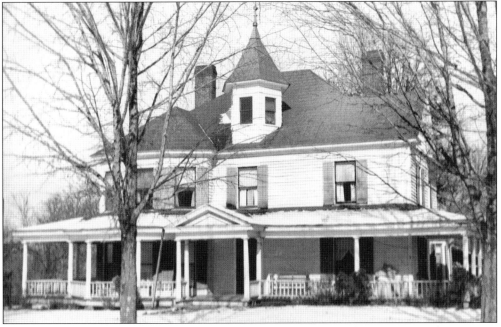

H. LUTHER AND ROBBIE SHOAF LEONARD HOME. Luther and Robbie were married August 11, 1910. They spent most of their lives farming and selling their produce to the Winston-Salem Farmers Market. The house was a Queen Anne–style home. These hardworking folks cut all the timber used in constructing their home themselves. The home at one time had a screened porch, which has since been removed, on the right side. (Courtesy of Katherine Skipper.)

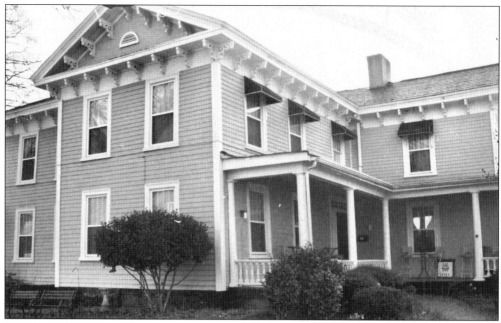

T. S. EANES HOUSE. Mr. Eanes was a prominent Lexington citizen. In 1908, he started the Lexington Ice and Fuel Company and also purchased the City Ice and Fuel Company in Thomasville. He served on the board of the Lexington Commissioners for seven terms. The house is now a bed and breakfast inn called the Bailey House. Neil Bonnett and Dennis Wiesick have been just a few who have frequented the inn since it opened in 1990. (Photograph by Bo Bennett.)

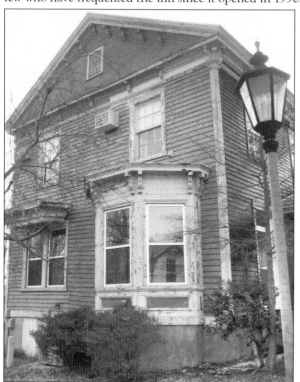

E. B. CRAVEN. This house was moved from Third Avenue to its present location on Center Street. The Craven house was originally located behind First Presbyterian Church and is the second-oldest building in the county. (Photograph by Bo Bennett.)

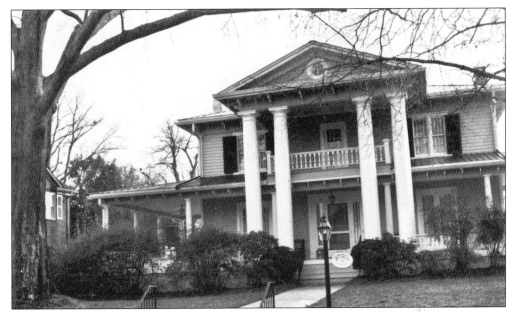

HILLDALE, C. 1854. This house, known as Hilldale, was moved in 1919 to its present location on West First Avenue. Through the years, a wraparound porch was added, as well as a Tuscan columned portico. A southern red oak seen in the front yard was inducted into the Lexington Treasured Tree Program in October 2001. Today it is the home of William McMurray. (Photograph by Bo Bennett.)

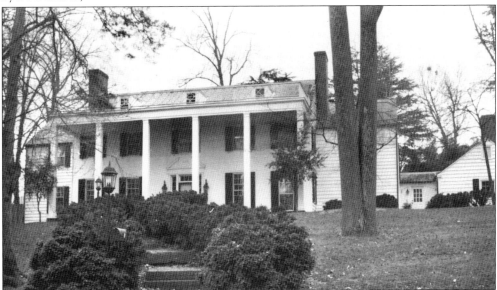

COLONIAL HOME, 1930. This house was built by G. W. Smith Lumber in the 1930s, during the Depression. Since many men were out of work, the builder was fortunate enough to be able to choose from some of the most talented craftsmen in the county. This home contained quality materials and workmanship that most homeowners could not afford during those difficult times. Children and grandchildren of those gifted workmen have helped Steve and Cathy Coles, the current owners, maintain this wonderful example of Davidson County craftsmanship. (Photograph by Bo Bennett.)

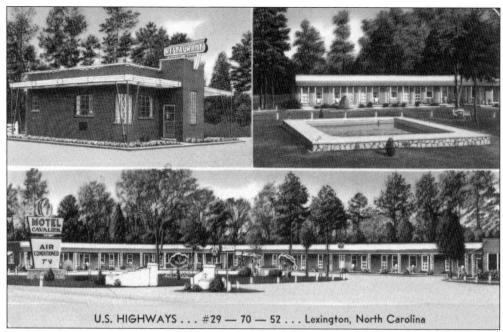

U.S. HIGHWAYS . . . #29 — 70 — 52 . . . Lexington, North Carolina

MOTEL CAVALIER. An open house was held at the Motel Cavalier's restaurant in December 1953 to let patrons try the new Cavalier cuisine. The motel opened in June 1951 with 10 units, and 9 additional units were eventually added. Clayton Foster was the motel's manager and was assisted by Mr. and Mrs. N. H. Foster. This establishment was touted as a "Handsome Motel and Restaurant" by the *Lexington Dispatch* on December 17, 1953.

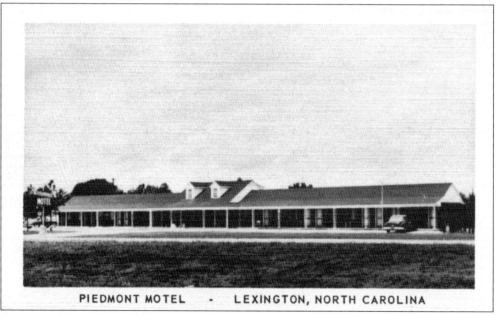

PIEDMONT MOTEL - LEXINGTON, NORTH CAROLINA

PIEDMONT MOTEL. Located on Piedmont Drive, this motel was built sometime in the 1950s. In the 1920s and 1930s, places to stay were usually shanties or cabins with a small sign out front. In the 1950s and 1960s, the signs were bigger and took on a lot more prominence, as they were trying to sell the hotel. Today the Piedmont Motel is the Quality Inn. (Courtesy of S. C. View.)

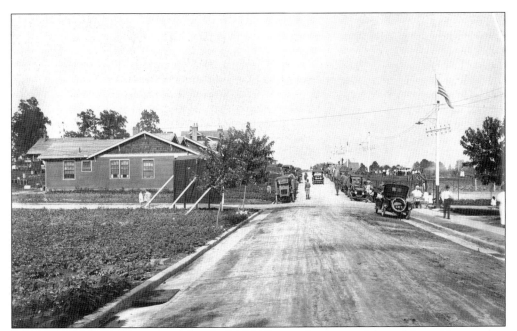

ERLANGER STREET. Erlanger was first the Mill Village in Lexington. Most of the residences were bungalow-style dwellings. The Erlangers made certain no two homes that looked exactly alike were built next to each other. In 1953, individual ownership of the homes was made possible for the residents, and many of the owners added their own personal touches to their homes. Ramona Byrd was born in an Erlanger home on Olympia Street on August 21, 1940. (Courtesy of Davidson County Historical Museum.)

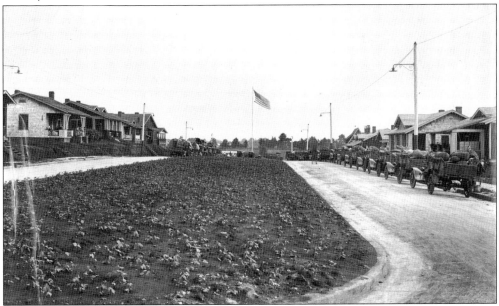

ERLANGER VILLAGE. Erlanger was incorporated into the City of Lexington in 1939. Military vehicles line the street in this Erlanger neighborhood. The construction on the mill began in 1913, and a self-sustaining community was established, lasting to this day. (Courtesy of Davidson County Historical Museum.)

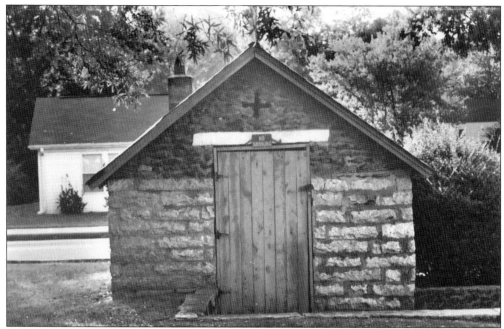

COLD STORAGE. This is a typical building that was built from stone and used to keep goods cool in the summertime. This building is still on the property of the Lexington City Cemetery today. These ice houses combined underground storage space for ice with an above ground structure. Many times, the ice was cut from ponds or creeks, or the houses were built on top of cool-water springs. Items such as meat, milk, and butter were kept in these houses. (Photograph by Bo Bennett.)

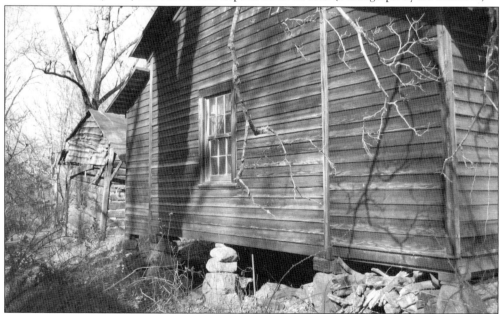

HOUSE ON ROCKS. Home owners would find the biggest rocks possible in a field so they could place them under their house to keep them from sinking. The rocks also served as a foundation to prevent termite infestation. When it became necessary to move a house, rocks and logs were used to roll them to other locations. (Photograph by Bo Bennett.)

Four

ROADS, RAILS, AND AIR

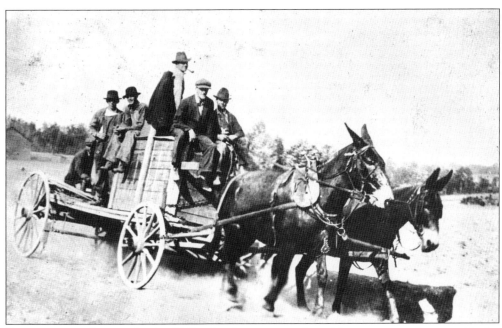

BUILDING THE ROADS. In the 1920s, the first structured road improvements began, with the owner of the *Dispatch*, Col. H. B. Varner of Lexington, forming the North Carolina Good Roads Association. The formation of the association brought about major improvements for the state and county roads. The group's goal was to "get the county out of the mud." The State Highway Commission, formed in 1915, issued a bond in the amount of $300,000 for improvements, and the grading of sand and clay roads was begun. (Courtesy of Jesse Hargrave Wright.)

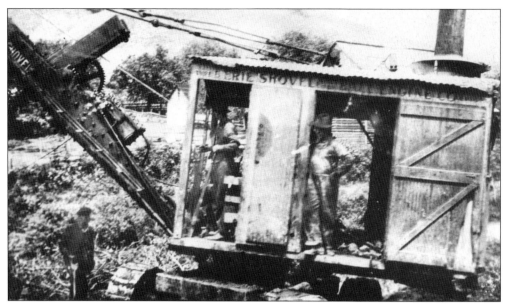

ERIE SHOVEL. The Ball Engine Company brought in this steam shovel to facilitate road construction. This photograph shows the two people necessary to operate the machine. One person controlled the huge shovel, while the other person fed fuel into the boiler. It was not until the 1930s or early 1940s that they were operated by gas or diesel engines. (Courtesy of Jesse Hargrave Wright.)

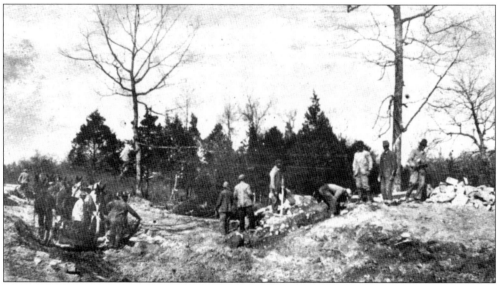

HARD WORKERS. Many long, hot hours were required to bring the roads into being. The men pictured use pickaxes, wagons, and donkeys. They lived in tents while working on the roads. The man to the right of the animals is holding the reins, while the man to the left guides the plow used to loosen the roadbed. The other men use picks and shovels to clear rocks and stumps out of the way. Six separate crews with wagons worked on this stretch of road. (Courtesy of Jesse Hargrave Wright.)

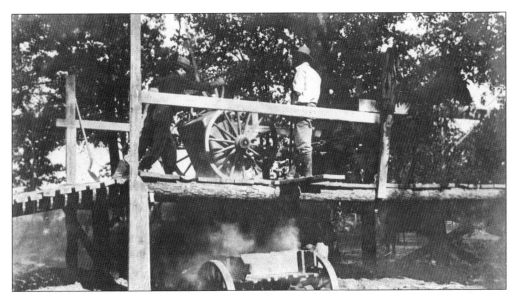

WHEELBARROW. In the absence of trucks and road graders, horse-drawn wagons were used to haul dirt and gravel. A cart can be seen here dumping materials into the wagon below. Notice the iron wheels on the wagon instead of wood. Wooden wheels were not durable enough for this type of heavy construction. (Courtesy of Jesse Hargrave Wright.)

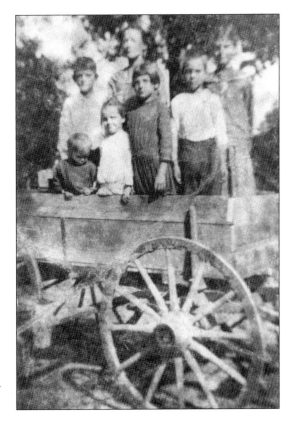

WAGON RIDE. Wagons similar to the one pictured here were commonly used by residents to transport materials to and from town. The seven children posing in the wagon are probably all related to each other, as the families were close-knit and helped each other by working side by side on family farms. (Courtesy of Davidson County Historical Museum.)

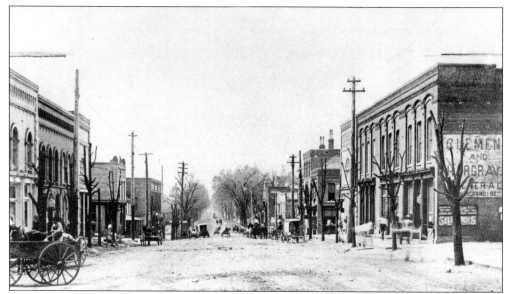

DOWNTOWN. The roads in downtown Lexington in the early 20th century were still unpaved. As late as February 1936, the roads were so muddy that school trucks could not pass over them. (Courtesy of Davidson County Historical Museum.)

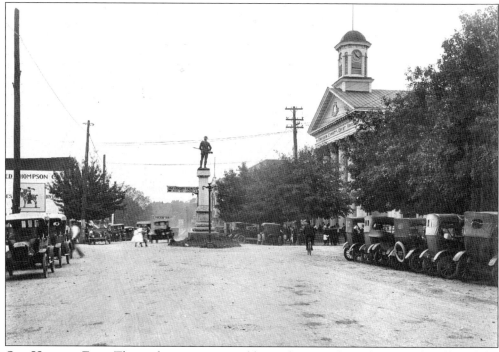

OLD HICKORY FAIR. The roads were in reasonable condition in the early 1930s; this allowed the townspeople to flock to fairs such as the Old Hickory Fair. They came by car and on bicycles. This was one of many fairs that Lexington hosted. The most prominent fair was the Davidson County Agricultural fair, which started on Fairview Drive and moved to its present location on Old Greensboro Road in 1946, where it continues to this day. (Courtesy of Davidson County Historical Museum.)

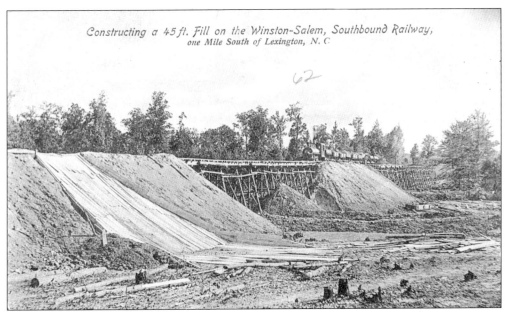

Constructing a 45 ft. Fill on the Winston-Salem, Southbound Railway, one Mile South of Lexington, N. C.

CONSTRUCTION FILL. This *c.* 1915 postcard shows the construction of a 45-foot fill on the Winston-Salem southbound railway one mile south of Lexington. (Courtesy of the North Carolina State Archives.)

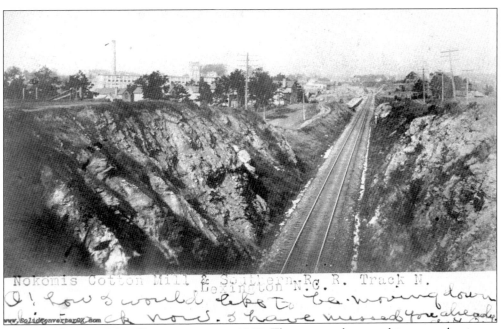

NOKOMIS COTTON MILL PHOTOGRAPH, C. 1900. The person who sent this postcard writes to his loved one, "O, how I would love to be moving down the track right now. I have missed you already." (Courtesy of S. C. View.)

51

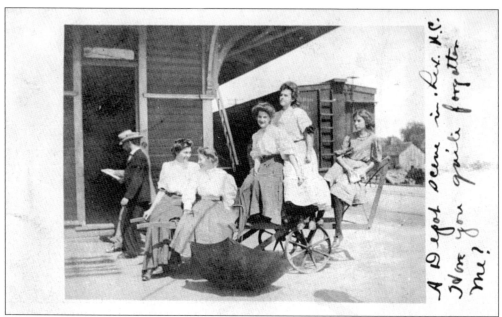

WOMEN AT LEXINGTON DEPOT, C. 1907. The women pose for a snapshot before departing for their trip. They were wearing typical fashions of the era—dresses or shirts with high necks, long sleeves, and long skirts. This type of dress was worn more by country women for modesty and to protect the wearer from the weather. Country women did not wear as many petticoats, giving the skirts a straighter look. (Courtesy of Davidson County Historical Society.)

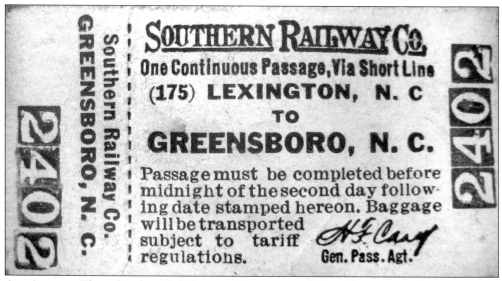

ALL ABOARD. The railroad ran daily between Lexington and Greensboro. According to the ticket shown here, "Passage must be completed before the second day following date stamped hereon." (Courtesy of Jesse Hargrave Wright.)

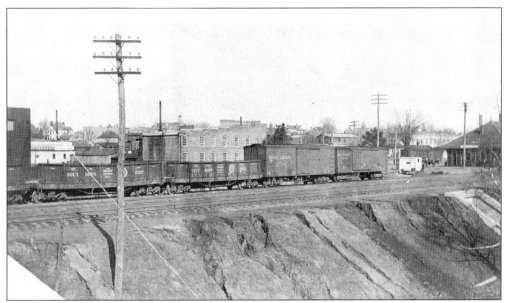

BOX CARS AND OPEN CARS. In 1911, the Southern Railroad track was laid between Winston-Salem and Lexington. Initially steam locomotives hauled Southern's passenger and freight trains filled with furniture, textiles, tobacco, and produce. The first diesel engine came along in 1941, and all the Southern's steam engines were replaced by 1953, thus creating the first major railroad in the United States to convert totally to diesel power. (Courtesy of Katherine Skipper.)

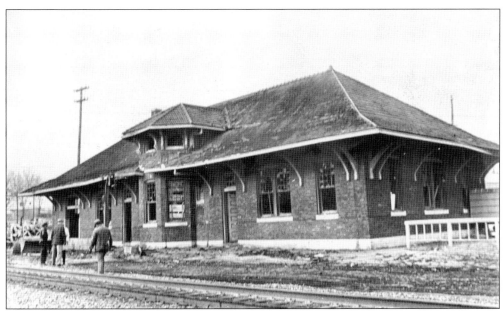

LEXINGTON RAILROAD STATION. Before this brick building was erected, the first Lexington railroad depot was made out of wood and had two sets of stairs going down to the tracks from the platform. It featured the Lexington name and bars on the windows. Presidential whistle-stops have been a common occurrence through the years as candidates garnered votes through the area. (Courtesy of Katherine Skipper.)

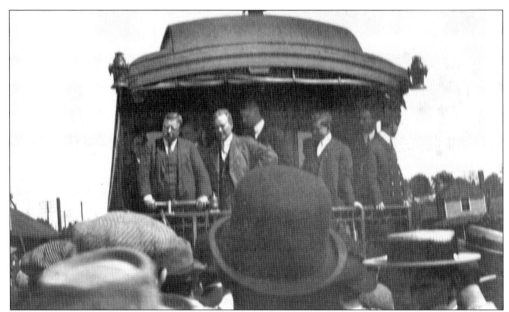

CAMPAIGN TRAIL. This text was engraved on a gold plate under the picture: "Tuesday October 12, 1912 Special Train of Col. Theodore Roosevelt and party touring the state Col. Roosevelt addressing the citizens of Lexington." Zeb Walser served as Theodore Roosevelt's state campaign manager in 1912. He is seen here with Roosevelt. It is speculated that if Teddy Roosevelt won when he ran on the Bull Moose ticket, Zeb would have been appointed attorney general of the United States. (Courtesy of Vance and Joy Walser.)

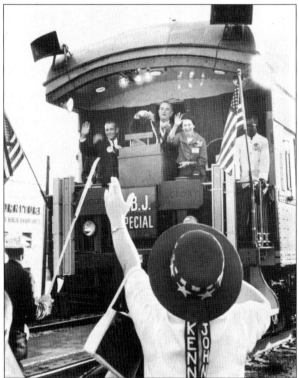

LYNDON JOHNSON. The "L.B.J. Special" is seen here in 1960 on the Southern Railway tracks in front of the United Furniture Plant. The train was carrying Lyndon and Lady Bird Johnson. Standing to their right is H. Cloyd Philpott. (Courtesy of the Edward C. Smith Civic Center.)

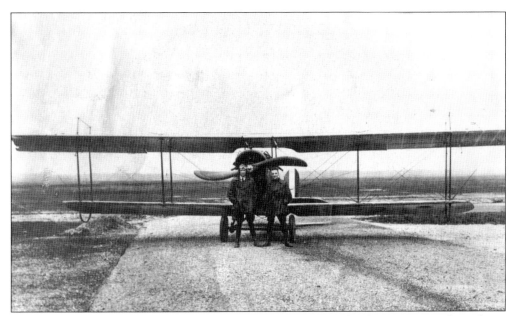

BIPLANE. In the early 1920s, William Boeing and Edgar Gott, his first cousin, took a ride on a Curtiss Aeroplane and Motor Company–designed biplane that required the passenger and the pilot to sit on the wing. After seeing the construction of the plane, the men believed they could design a better biplane, and they did. It was a good thing for these two unidentified men, as the old design did not seem very sturdy, safe, or practical. (Courtesy of Davidson County Historical Museum.)

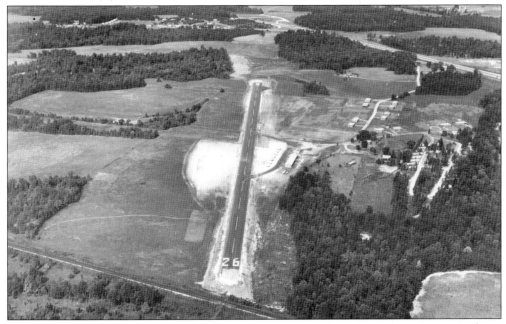

AERIAL OF AIRPORT LANDING STRIP. This early photograph of the Lexington airport shows the 950-foot-long landing strip. After a year, it was extended to 2,300 feet and later out to 3,000 feet. In 1967, airport owner Joe Dillard leased it to the city, and the landing strip was graded and paved, gaining an additional 300 feet of runway. (Courtesy of Joe Dillard.)

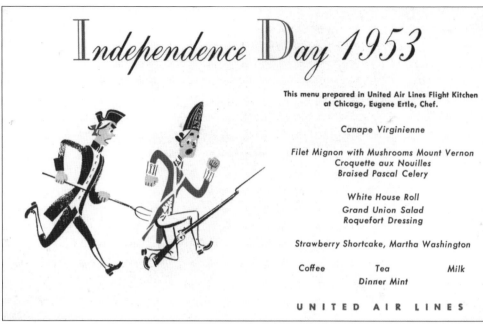

Independence Day 1953

This menu prepared in United Air Lines Flight Kitchen at Chicago, Eugene Ertle, Chef.

Canape Virginienne

Filet Mignon with Mushrooms Mount Vernon
Croquette aux Nouilles
Braised Pascal Celery

White House Roll
Grand Union Salad
Roquefort Dressing

Strawberry Shortcake, Martha Washington

Coffee Tea Milk
Dinner Mint

UNITED AIR LINES

INDEPENDENCE DAY, 1953. Hughes Martin, the executive vice president of Belk-Martin in Lexington, traveled quite frequently. This interesting dinner menu was served to the guests aboard an Independence Day United Airlines flight. Filet mignon is something that you sure don't get on flights today!

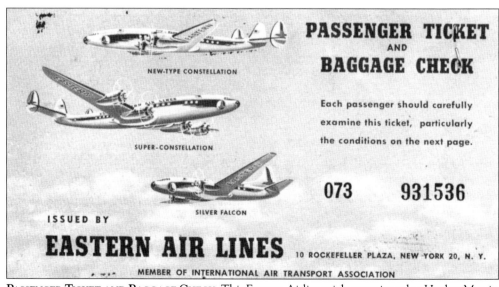

PASSENGER TICKET
AND
BAGGAGE CHECK

NEW-TYPE CONSTELLATION

SUPER-CONSTELLATION

SILVER FALCON

Each passenger should carefully examine this ticket, particularly the conditions on the next page.

073 931536

ISSUED BY

EASTERN AIR LINES 10 ROCKEFELLER PLAZA, NEW-YORK 20, N. Y.

MEMBER OF INTERNATIONAL AIR TRANSPORT ASSOCIATION

PASSENGER TICKET AND BAGGAGE CHECK. This Eastern Airlines ticket was issued to Hughes Martin in the 1930s. The tickets from the past had a lot more character than the e-tickets of today.

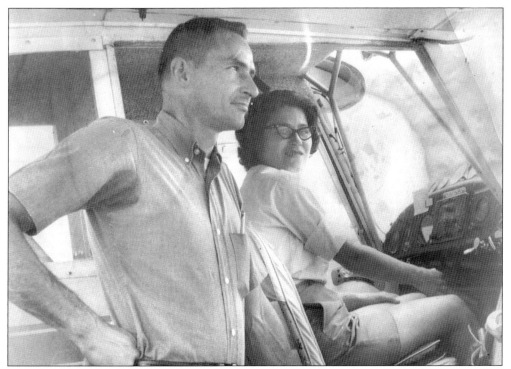

Joe Dillard and Wife. Joe Dillard is standing next to his wife, Joyce, who is seen sitting in the cockpit of one of his planes. Mrs. Dillard learned to fly solo and had about 8 or 10 hours of flying time. (Courtesy of Joe Dillard.)

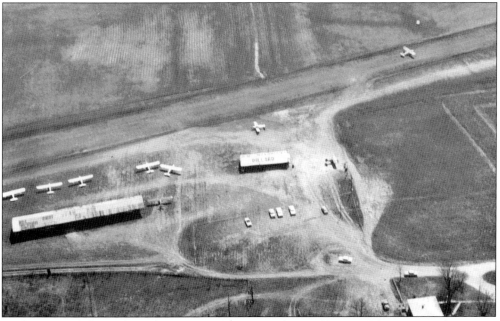

Airport. The hangers and airplanes can be seen in this aerial view of the airport. The airport had the capability of housing up to 33 planes in its hangers. At one time, Mr. Dillard had 50 airplanes based at his airfield. (Courtesy of Joe Dillard.)

POLICE WAITING. An early-morning charter turned into a surprise for pilot Joe Dillard. When a good-looking young man in his early 20s said he wanted a charter to West Virginia, Dillard obliged, even letting the man put his new Corvette into a hanger at his airport. En route to the requested destination, the passenger decided to go to a different airport. Dillard obliged and dropped off his customer at the new location and returned to Lexington to awaiting police officers. To his shock, he learned his fare had just robbed a bank! Joe took a lot of good-natured ribbing. The bandit was eventually caught. (Courtesy of Joe Dillard.)

Five

LEXINGTON PROFILES

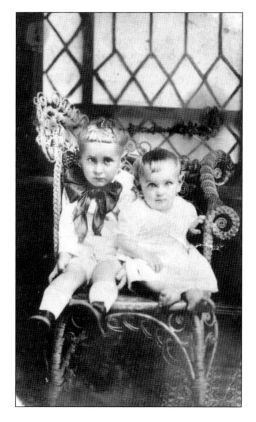

ARDELL LANIER. Rudolph Lanier (left) and Ardell Lanier pose for this early-1922 postcard. Ardell, at the age of 20, purchased his brother-in-law's hardware store and decided to make a go of it. The Lanier slogan became "If we don't have it and we can't get it, you don't need it." In the early years, Mr. Lanier ran his store with only one other employee. He started with 1,600 square feet, and today his store has expanded to 85,000 square feet. (Courtesy of Ann Lanier Easter.)

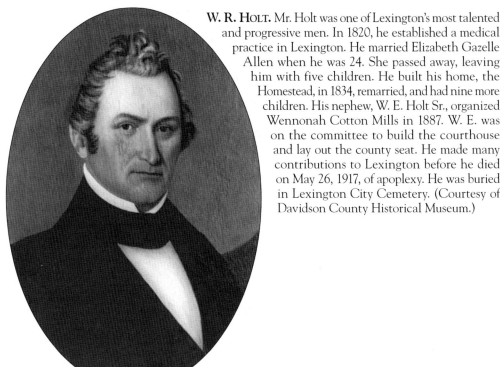

W. R. HOLT. Mr. Holt was one of Lexington's most talented and progressive men. In 1820, he established a medical practice in Lexington. He married Elizabeth Gazelle Allen when he was 24. She passed away, leaving him with five children. He built his home, the Homestead, in 1834, remarried, and had nine more children. His nephew, W. E. Holt Sr., organized Wennonah Cotton Mills in 1887. W. E. was on the committee to build the courthouse and lay out the county seat. He made many contributions to Lexington before he died on May 26, 1917, of apoplexy. He was buried in Lexington City Cemetery. (Courtesy of Davidson County Historical Museum.)

DR. JACOB CALVIN LEONARD. At age 16, Leonard was hired to teach public school. Later he went on to attend Catawba College and was a member of the first graduating class in 1889. Dr. Leonard was also the founder and pastor of the First Reformed Church. He kept meticulous records of the money in and out of the church and recorded the various ceremonies he performed. (Courtesy of Katherine Skipper.)

JONES TILDEN HEDRICK. Born on December 4, 1876, Hedrick was one of Davidson County's leading businessmen. In 1899, he opened the Lexington Grocery Company with three other men. The company became a great success. For those early years, he was quite an entrepreneur, even owning property—a citrus orchard and packing plant—in Florida. He was a charter member of the First Reformed Church and was chosen as one of the first deacons. Later he served as an elder until his death in 1938. (Courtesy of Katherine Skipper.)

MOFFITT FAMILY. The Moffitts are shown with their six children. From left to right are (first row) William Henry Moffitt Jr., mother Mary Lou Sowers Moffitt, Rosa May Moffitt, and father William Henry Moffitt; (second row) Oscar Peyton Moffitt, Joseph Vestal Moffitt, Perle Sowers Moffitt, and Ralph Davis Moffitt. (Courtesy of Merle and Jerry Hodges.)

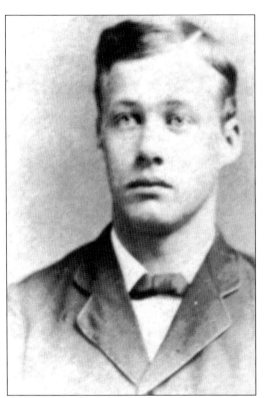

ZEB WALSER. On October 4, 1886, Zeb Vance Walser was admitted to the Bar of North Carolina. He had a local law practice and was an active member and leader of the North Carolina House of Representatives beginning in 1888 and in the State Senate in 1891. By 1895, Zeb returned to the House of Representatives. By 1896, Zeb was elected attorney general of North Carolina and further served as the official reporter for the Supreme Court of North Carolina in 1900. He also served as Theodore Roosevelt's state campaign manager in 1912. (Courtesy of Vance and Joy Walser.)

THEODORE ROOSEVELT AUTOGRAPH. Zeb Walser was Theodore Roosevelt's North Carolina campaign manager in 1912. During that time, they became friendly, and Roosevelt autographed one of his books, *The Winning of the West*, for Zeb. (Courtesy of Vance and Joy Walser.)

WEDDING PICTURE. The wedding dress worn by Clara Mai Thompson Moffitt can be seen at the Davidson County Historical Museum. Ms. Thompson married Joel V. Moffitt Sr., who was the son of William Moffitt. (Courtesy of Davidson County Historical Museum.)

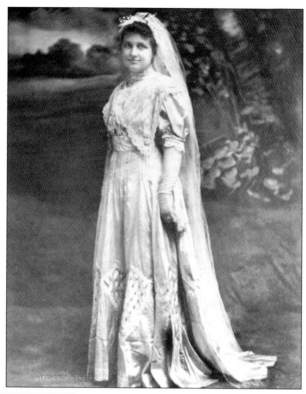

JOEL V. MOFFITT JR. Seen here as a youngster, Moffitt led an accomplished life. At 16, he joined the Wennonah Cotton Mills on January 1, 1900, and worked at the mill for 48 years. He performed a variety of duties including bookkeeper, shipping clerk, and cotton weigher. He founded Peerless Mattress Company with three others and was the cofounder of Dacotah Cotton Mills with C. A. Hunt Jr. He served as president of the Commercial Bank of Lexington from 1932 until his death on May 31, 1973. (Courtesy of Merle and Jerry Hodges.)

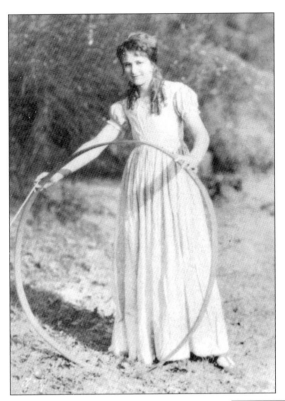

ELLA LEONARD RAPER. Miss Raper married Casper Timberlake on September 1, 1925. She was born in Lexington and graduated from Lexington High School in 1923. She attended Salem College for two years. She and her husband were members of the First United Methodist Church. Raper belonged to the Women's Missionary Society and taught Sunday school. Her family's roots go back in Davidson County at least 200 years. (Courtesy of the Bob Timberlake Gallery.)

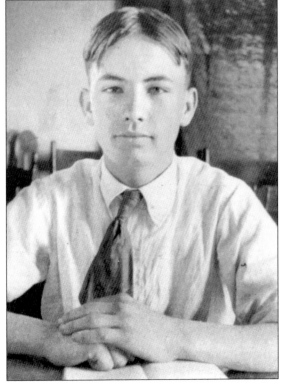

"PAPPY." Known to many in his later years as "Pappy," Casper Hill Timberlake was born October 4, 1905, in Lexington. Timberlake attended Lexington City School and played on their first football team. A newspaper clipping with a photograph of all the players can be seen hanging on the wall at Southern Lunch. He attended Duke University and also briefly attended the U.S. Naval Academy in Annapolis. Timberlake played with the symphony, jazz, and band orchestras while attending Duke. (Courtesy of the Bob Timberlake Gallery.)

BOB TIMBERLAKE. On his birthday in 1950, Bob's present was a brand-new shotgun. He is seen here trying his luck at bird hunting. Bob started painting in January 1970. His first professional show opened in May that year. It was a huge success and sold out in three days. In the fall of 1977, he opened a gallery with a staff of two. Today his artwork and home furnishings are known and appreciated worldwide. (Courtesy of the Bob Timberlake Gallery.)

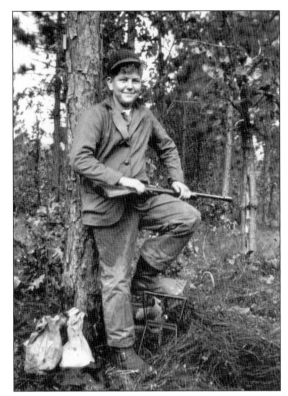

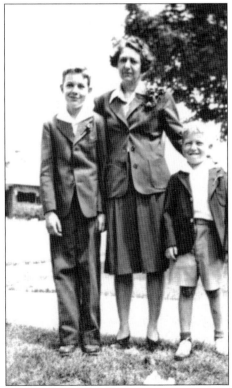

TIMBERLAKE FAMILY. Ella Timberlake is shown her with her two sons, Casper Hill "Tim" Timberlake Jr., born November 29, 1932, and Bob Timberlake, born January 22, 1937. Tim Timberlake studied at the University of North Carolina, graduated in 1954, and became the president of North Carolina LP–Gas Association. He married Hazel Slaughter, who also attended UNC. (Courtesy of the Bob Timberlake Gallery.)

MR. AND MRS. INGRAM. Estella Shipton Ingram and Albert J. "Cap" Ingram are seen here on their wedding day, August 27, 1904. Both had roads named after their families. As a compromise, the couple decided to build their home where the Ingram and Shipton roads merged. They raised seven children on their self-sufficient farm along with a variety of vegetables and animals. The Ingram home place still remains today. (Courtesy of Jimmie Jean Hunt.)

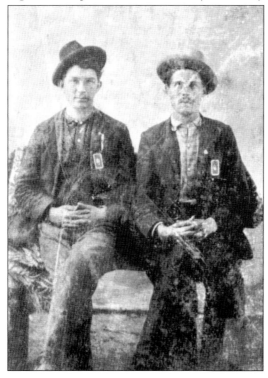

C. B. AND CAP. Cap Ingram (right) and his friend C. B. Wall Colbert took a day off from their busy farming schedule to pose for this picture. (Courtesy of Jimmie Jean Hunt.)

KATE V. WORKMAN. Kate was the daughter of Cornelius and Margaret V. Workman. She is seen with upswept hair and the high-necked blouse that was common in the 19th century. (Courtesy of the North Carolina State Archives.)

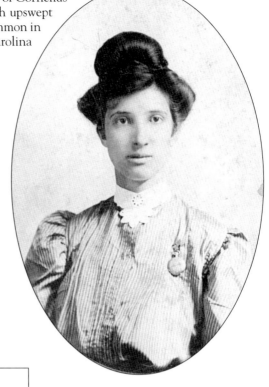

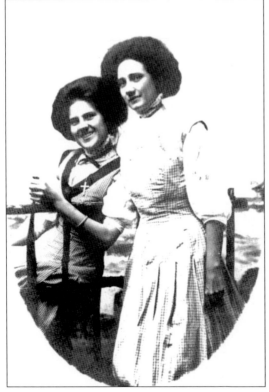

RELIGIOUS WOMEN. The girls' hairstyles are indicative of the early 20th century. This style was associated with a beautiful, confident appearance. The girls look as though they may have been sisters. (Courtesy of Davidson County Historical Society.)

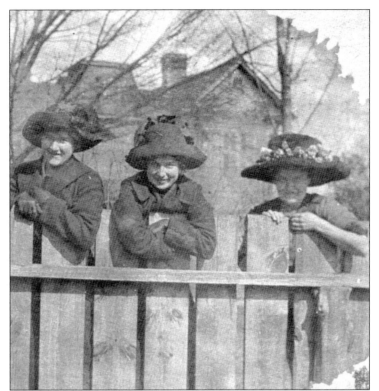

THREE WOMEN IN HATS. In the first decade of the 20th century, hats were typically worn by women in the daytime and usually had veils, feathers, flowers, and ribbons. These women look as though they are having a fun day together. (Courtesy of Merle and Jerry Hodges.)

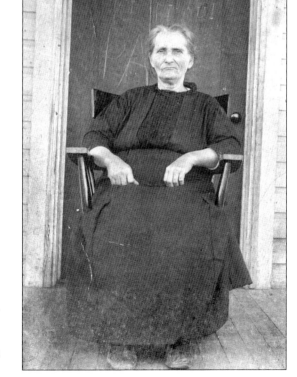

KEEP OUT PA. This 1910 postcard was taken in jest with the words "Keep Out Pa" carved into the wooden door behind the woman in the rocking chair. Though this was done as a gag, the woman guarding her front porch looks right formidable. (Courtesy of Davidson County Historical Society.)

BIBLE LADY. North Carolina is located in the buckle of the Bible Belt. It was not unusual to see people reading the Bible on any given day. (Courtesy of Davidson County Historical Museum.)

PATSY MABRY. Gertrude Mabry, 95 years old, of Lexington and a parishioner of Shady Side Methodist Church, was able to identify this lady as her great-grandmother. She was unsure as to where she was employed, but many of her relatives at the beginning of the 20th century worked for the Hargraves. (Courtesy of Davidson County Historical Museum.)

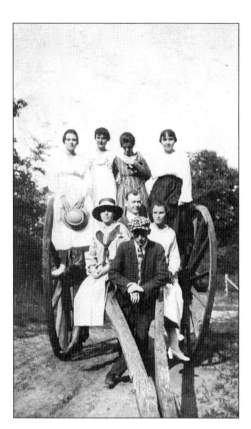

PEOPLE ON A WAGON. Two men are posing with six young ladies. Included here are Alice Burton and Erostus, her husband (the couple in the hat and cap); Virgil and Minnie Rhodes; Pearl Leonard (in the striped dress); Lee Grimes; and Beuleth Holder. (Courtesy of Davidson County Historical Museum.)

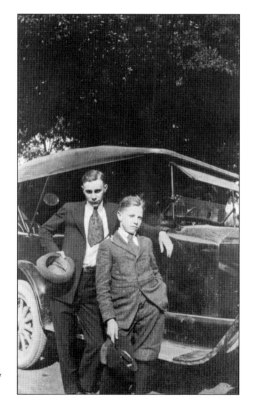

READY TO GO. These boys, seen in the 1920s, look as though they are ready to go have some fun in Lexington. (Courtesy of Davidson County Historical Museum.)

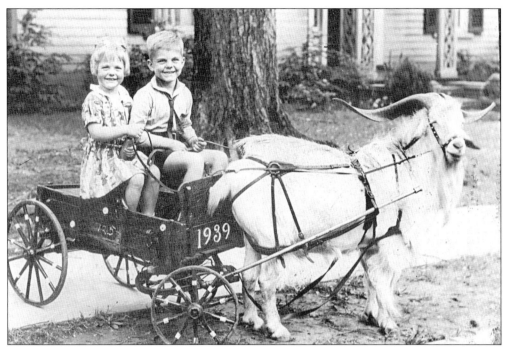

RIDES. In the 1920s, it was not uncommon for photographers to come around and offer goat rides to children and take their photographs. The practice continued for many years, as is evident in this 1939 photograph. (Courtesy of Jesse Hargrave Wright.)

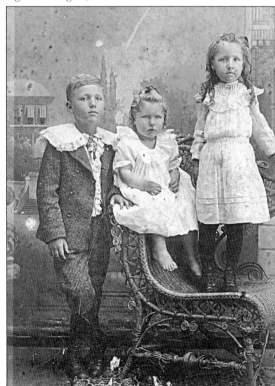

CHILDREN. Family photographs such as these are a treasure. The two little girls stood on a chair in the shape of a sleigh posing with their brother for this cute family photograph. (Courtesy of Davidson County Historical Museum.)

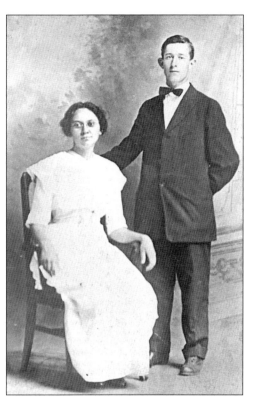

MR. AND MRS. MILLER. Hugh Lindsay Miller and Emma Nancy Owen Miller lived on the Miller Farm most of their life. The couple had six children who all helped with the tobacco, grain, corn, and potatoes that were raised. The family enjoyed having church socials and Sunday school parties at their home. (Courtesy of Davidson County Historical Museum.)

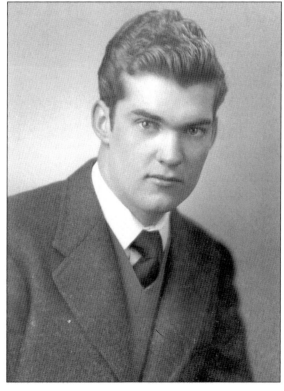

ZEB "BUD" LITTLE. Bud lived with his aunt, Mrs. Zeb Z. Grubb, whose husband built and operated one of the first airstrips in Lexington. It was located behind his company, Grubb Oil. Grubb was killed in a plane crash in the Yadkin River. After Grubb's death, Bud inherited the Grubb Oil Company and ran the Lexington airstrip. Lou Adkins has fond memories of flying all over Lexington with her cousin Bud. Unfortunately, at 28, he was killed in a plane crash while flying to see a Virginia-Carolina game. (Courtesy of the Little family.)

VACATION TIME. Hughes Martin, the executive vice president of Belk-Martin for 40 years, poses with an unidentified woman. This photograph was probably used in an advertisement for the Belk-Martin store.

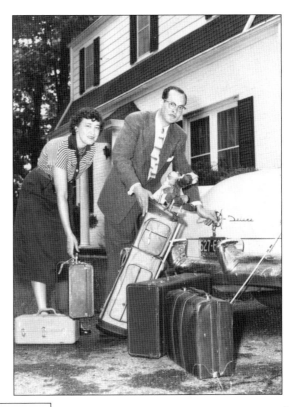

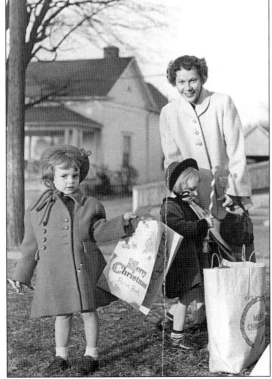

MERRY CHRISTMAS. This young mother and her children appear to be getting ready for Christmas, as their shopping bags have "Merry Christmas" written on them. The little girl holding the candy cane eagerly anticipates enjoying her treat. (Courtesy of Davidson County Historical Museum.)

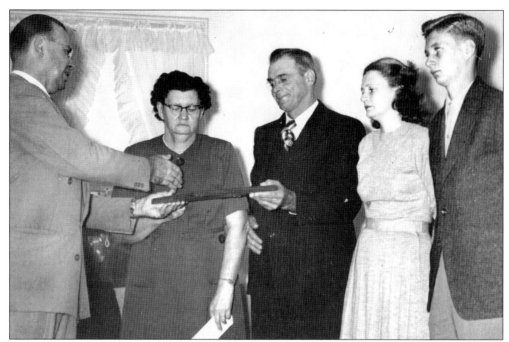

AWARDS. In 1951, Jeff Fritts received a well-deserved award for Farmer of the Year from the *Progressive Farmer* magazine. He was accompanied by his wife, Mae, and his children, Rachael and Gene. (Courtesy of Gene Fritts.)

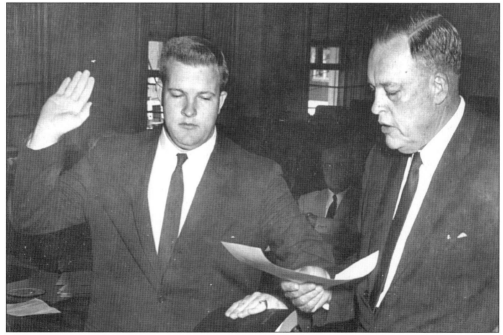

SWEARING IN. Gaither Walser is seen here being sworn in by his father, Don A. Walser, who was born in 1899 to Mr. and Mrs. Zeb Walser. Don Walser joined his father's law firm when he was just 19. Gaither, who was the last attorney sworn in at the old courthouse, joined the firm in 1957 and worked at the law firm throughout his career. (Courtesy of Vance and Joy Walser.)

Six

IN DEFENSE OF FREEDOM

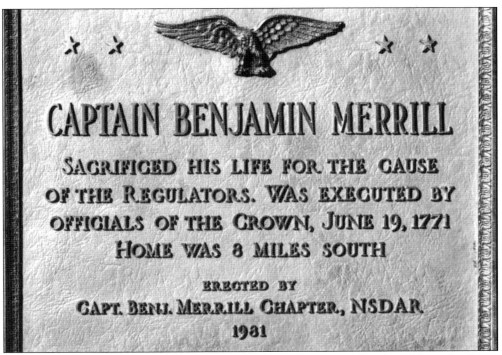

BENJAMIN MERRILL. This monument is located in front of Conrad and Hinkle in the Court Square. It is dedicated to the memory of Benjamin Merrill, a Regulator who was part of the freedom fighters trying to regulate British authority so it would be fair to all settlers. Benjamin Merrill was the head of the largest group of Regulators of 300 or so men from the Jersey Settlement. Upon hearing this news, Gov. William Tryon sent Col. Hugh Waddell to catch him. He could not, so he sent 1,500 British on June 19, 1771, to do the job. Merrill and 12 others were caught and hanged for treason. The remaining Regulators were forced to sign an oath of loyalty to the British. Merrill became a martyr for the people in North Carolina for the cause of freedom. (Photograph by Bo Bennett.)

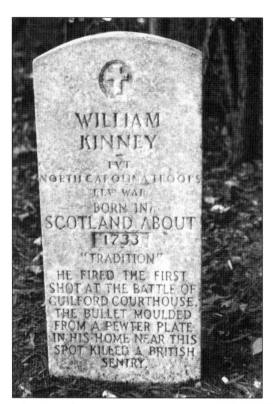

PVT. WILLIAM KINNEY. This grave marker is found in an out-of-the-way corner of tall timber in Lexington, having been moved twice before to make room for the ever-expanding town. This brave private shot the first bullet during the Battle of the Guilford Courthouse, which is said to have been one of the deadliest and hardest-fought battles of the Revolutionary War. This battle contributed to the 13 colonies being given their freedom. God bless your bravery, Private Kinney. (Photograph by Bo Bennett.)

LETTER OF TORTURE. Attorney Thomas Settle wrote to Gov. Zebulon B. Vance regarding the arrest and torture of civilians by soldiers in 1866. Some of the tactics used on women were slapping them, hanging them by their thumbs from a tree, and crushing their fingers under fence posts. (Courtesy of the North Carolina State Archives.)

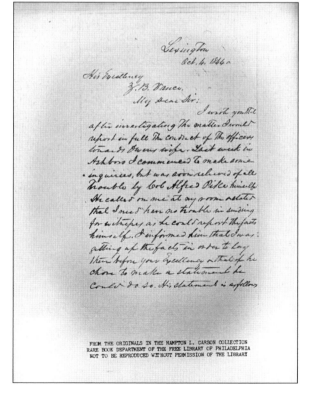

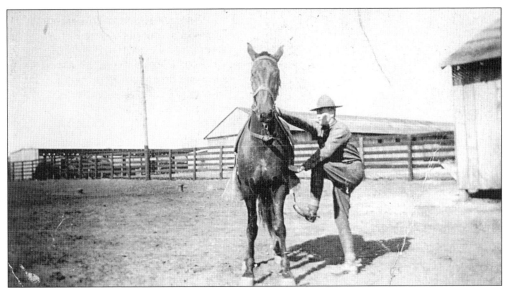

MOUNTING HORSE. Pvt. K. Latham saddled his horse in preparation to ride with the 116th Cavalry during World War I. (Courtesy of the North Carolina State Archives.)

PHOTO BY HITCHCOCK

FIRST MEN. These brave men were the very first who volunteered for the First World War from Davidson County. From left to right, they are Arthur Thomason, Raymond Bowers, Mod Stout, Sam Welborn, Joe Everhart, Archie Dorsett, William Raper, and Raymond Ward. (Courtesy of Edward C. Smith Civic Center.)

MARVIN LEE MORRIS OF LEXINGTON. From 1939 to 1945, Morris served in the 404th Infantry in the U.S. Army. He was with the D-Day forces at Utah Beach and fought in France and Germany, being wounded only once. (Courtesy of the North Carolina State Archives.)

R. G. YARBOROUGH. PFC Roby Gray Yarborough, seen around 1918, was in Company A, 3rd North Carolina Regiment, during World War I. His company was also known as Company A, 120th Regiment. (Courtesy of the North Carolina State Archives.)

Seven

EXCELLENCE IN EDUCATION

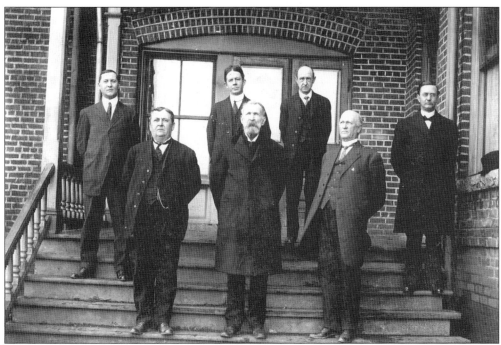

BOARD OF DIRECTORS. Lexington's first school board is seen posing in front of the Robbins School. The school was built in 1907 and was the first public school in Lexington. The school was named after Capt. Frank C. Robbins. Included here are Walter H. Mendenhall, banker; Dr. E. J. Buchanan, doctor; Capt. Frank C. Robbins; Dr. J. C. Leonard Jr., minister; R. E. B. Graven; Emery E. Roper, Esq; and an unidentified man. The building is no longer used as a school and is now the Robbins Recreation and Sports Field. (Courtesy of Davidson County Historical Museum.)

ROBBINS SCHOOL. A sketch of the Robbins School has been artistically placed on a piece of the actual blackboard that came from the school. The school's alma mater was sung to the author by Jerry and Merle Hodges: "Oh Robbins, Dear Robbins we pledge now to you our love and affection both justly your due. Go forward not backward we'll all keep in step and onward go marching with vigor and pep." (Courtesy of Merle and Jerry Hodges.)

LEXINGTON FEMALE ACADEMY. In November 6, 1899, an advertisement ran for the school: "A High Grade School For Boys and Girls special attention given to music art and elocution. W. J. Scrogs. A.M., Principal." In later years, the academy was rented to Jimmie Hunt's family as a private residence. (Courtesy of Jimmie Jean Hunt.)

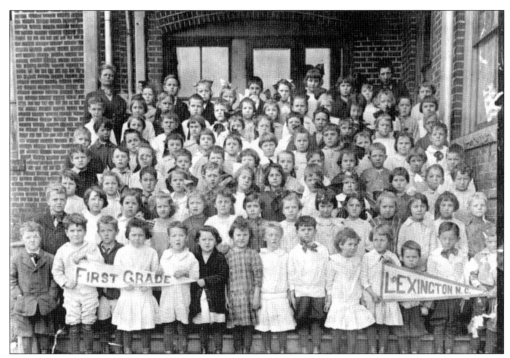

FIRST GRADE LEXINGTON. Apparently during this school year, the children were all dressed very similarly. The little girls had bobbed hair and wore tights and dresses while the boys wore knickerbockers. (Courtesy of Davidson County Historical Museum.)

REPORT CARD. Gaither Walser's teacher was very proud of his efforts and stated he was "very loyal to me and his school." He was promoted from the fourth grade. (Courtesy of Vance and Joy Walser.)

FOURTH REPORT

Gaither is a fine little boy. I have enjoyed teaching him this year. He is very loyal to me and the school.

ATTENDANCE

	1st	2nd	3rd	4th	Year
Days Absent	$\frac{1}{2}$	0	$\frac{1}{2}$	$\frac{1}{2}$ 1	2 $\frac{1}{2}$
Times Tardy	2	2	3	2	9

(Parent's Signature)

First Report *Mrs. Hon A. Walser*

Second Report *Jon E. Walson*

Third Report *Mr. Hon A. Walser*

Fourth Report

PROMOTION RECORD

DATE	PROMOTED OR RETAINED	GRADE
5/31	*promoted*	4 1/2

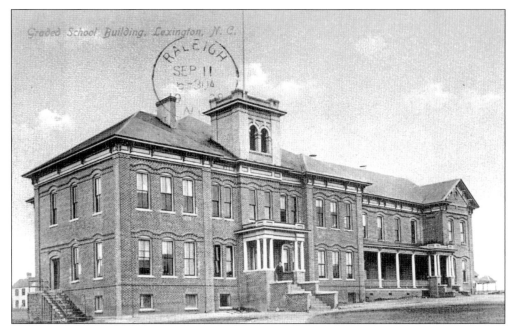

LEXINGTON GRADED SCHOOL. In 1903, this school was built to accommodate the growing student population of 760 pupils. (Courtesy of Davidson County Historical Museum.)

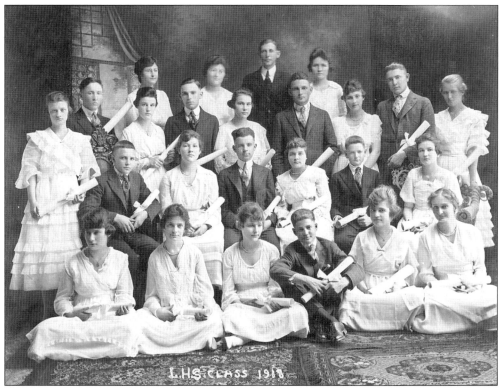

LEXINGTON HIGH SCHOOL CLASS OF 1918. Twenty-five proud graduates of the Lexington School System are shown here with their diplomas. (Courtesy of Davidson County Historical Museum.)

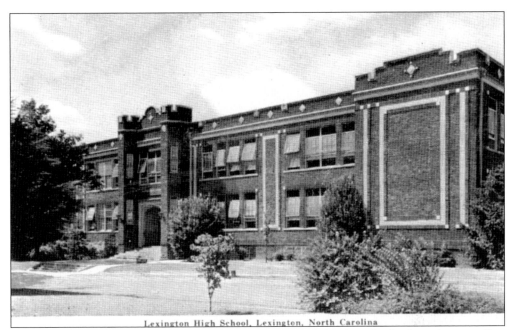

LEXINGTON HIGH SCHOOL. The original Lexington High School was built where the post office stands today. In 1945, after the Carolina Theater burned down, movies were shown in the school auditorium. (Courtesy of Davidson County Historical Museum.)

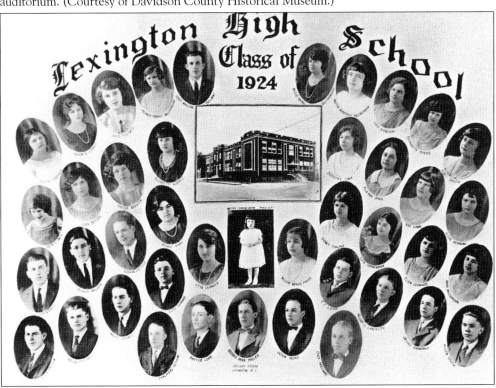

LEXINGTON HIGH SCHOOL CLASS OF 1924. Here are the graduates four years after the school opened. (Courtesy of Davidson County Historical Museum.)

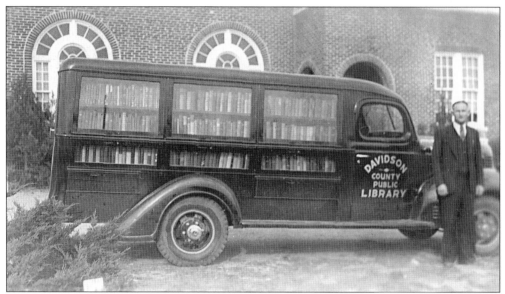

BOOKMOBILE. The first bookmobile for Davidson County was purchased in 1929. Davidson County was one of the first libraries in North Carolina to offer this service to residents throughout the county. In the early 1920s, bookmobiles were used to deliver books to schools, which then circulated the books to other locations. It was a great way to reach farmers and residents in the rural areas that might otherwise not have contact with the urban community. (Courtesy of Davidson County Historical Museum.)

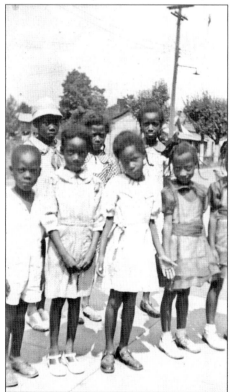

CHILDREN AT DUNBAR SCHOOL. In 1936, these children were photographed outside the first branch of the Lexington Library for African Americans. The library was located at the Dunbar School and available to the adults after school hours. This location was consolidated in 1968 at the 221 South Main Street location. (Courtesy of Davidson County Historical Museum.)

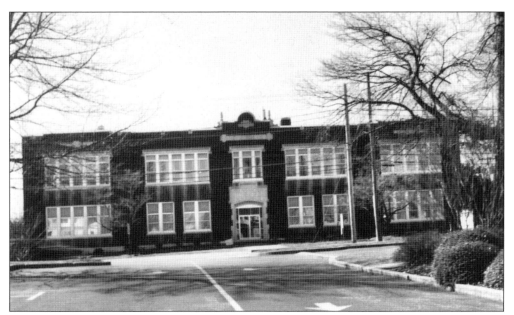

CECIL SCHOOL. David K. Cecil was one of Lexington's prominent citizens. He learned building from his brother and farming from his father. From 1925 until 1982, the Cecil School was the doorway to education for many children. Opal Johnson Wade was the principle of the school for 20 years. The Tudor Revival–style building is now home to the State Department of Agriculture. The auditorium has now been converted to a meeting area, and the building is considered a historical site. (Photograph by Bo Bennett.)

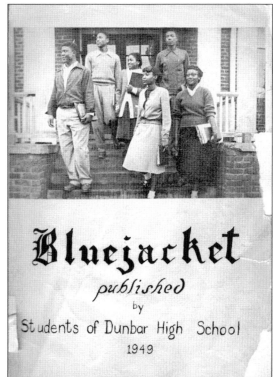

DUNBAR SCHOOL. The yearbook of Dunbar High School was named the *Blue Jacket*. This 1949 edition was created by the student body of Dunbar School. (Courtesy of Gertrude Mabry.)

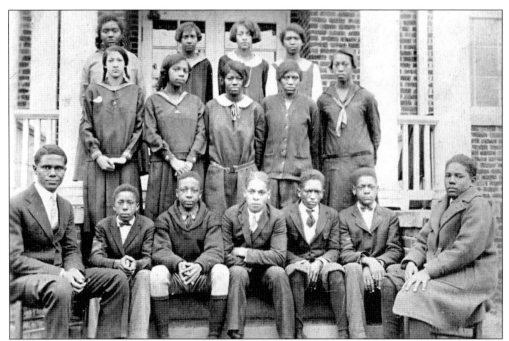

GRADUATING CLASS, 1928. Dunbar High School graduates are, from left to right, (first row) the principal, Garnett Sullivan, Cliff Pinkston, Arthur Neal Carter, John Hayes, Walter Miller (Gertrude's Mabry's boyfriend), and Willis Lowe; (second row) Ruth Neely, Dorothy Albright, Gertrude Mabry, Naomi Hargrave, and Alvia ?; (third row) Margaret Hayes, Beatrice "Bea" ?, Ida Mabry, and Lena Mae Hayes. (Courtesy of Gertrude Mabry.)

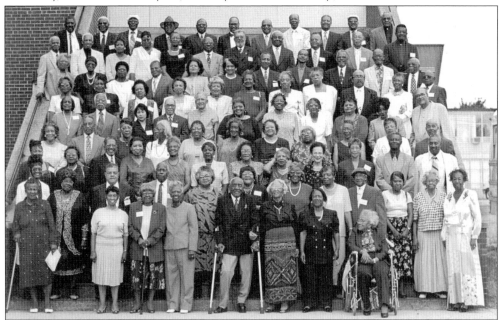

HIGH SCHOOL REUNION. These Dunbar school graduates were attending their class reunion. Some of the people seen in the photograph are from the 1928 graduating class above. (Courtesy of Gertrude Mabry.)

Eight

THRIVING LEXINGTON

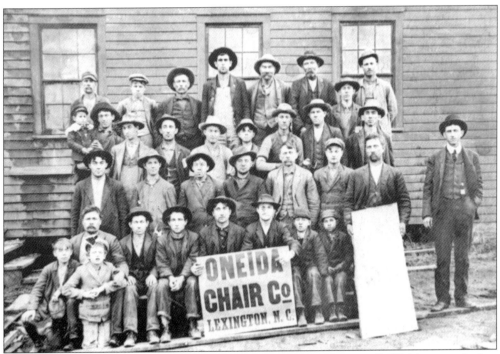

ONEIDA CHAIR COMPANY. In 1905, the president of this company was G. W. Mountcastle. Just a short six years later, the Lexington Chair Company acquired and modernized the factory. (Courtesy of the North Carolina State Archives.)

See List of the personal property of the
Lexington Copper Mining Company sold at
the Lexington Copper Mines and at Lexington N.C.
ctor. 20th 21st and 22d to satisfy an execution
in favor of John S. Williams.

Articles	Purchasers	Amount
1 Spring Wagon	Wiley Loftin	$ 10 .
1 Meat Box	G. W. Headrick	.35
1 pr Hames	W. A. Beak	.35
8 Wrenches	Jacob Headrick	.60
2 Crowbars	Thos. Kern	.50
4 pr Bows	Noah Headrick	.35
1 Tin Bucket & content	David Beak	.50
Lot Safety Fuse	W. Loftin	.25
2 Lamp Frames	Levi Beak	.15
2 do.	S. C. Ford	.20
2 do.	M. f. Peacock	.10
2 do.	Of W. Headrick	.10
2 do. with bush trove conveise	H. L. Workman	.15
Barrel and Powder	M. f. Peacock	.75
1 Wheelbarrow	W. A. Beak	.15
3 Empty Oil Barrels	F. W. Hunt	.50
3 do. do.	David Beak	.15
3 do. do.	A. W. Elliott	.25
1 Cultivator	A. H. Johnson	1.00
1 Double Plow	do.	.25
1 Subsoil do.	J. C. Miller	.15
	Carried forward	$ 14.10

LEXINGTON COPPER MINING COMPANY. Unfortunately this mining company fell onto hard times and had to sell off its personal property to, as the image at left says, "satisfy and execution in favor of John S. Williams." (Courtesy of the North Carolina State Archives.)

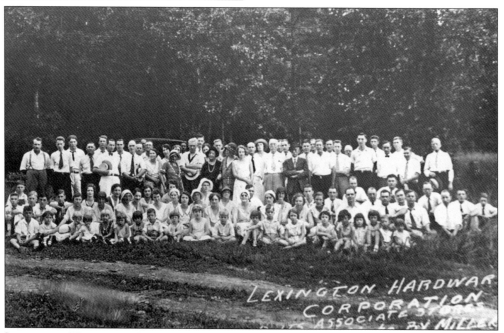

LEXINGTON HARDWARE PICNIC. On August 13, 1931, Maurine, Jesse, Bill, and James Perryman were just some of the employees who attended the Lexington Hardware Picnic. In business from the turn of the century, Lexington Hardware was located on North Main Street and was sold in 1967, becoming Ace Hardware. (Courtesy of Davidson County Historical Museum.)

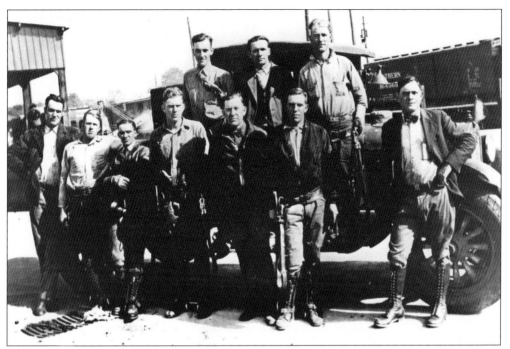

LINE MEN. These men were instrumental in bringing electricity to the thriving town of Lexington. The residents would be able to enjoy the benefits of electrical appliances such as washing machines, refrigerators, and televisions. (Courtesy of Davidson County Historical Museum.)

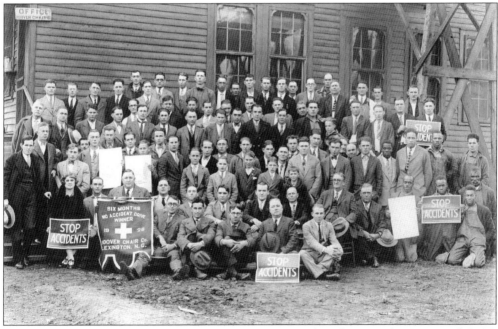

STOP ACCIDENTS. The Hoover Chair Company was purchased in 1918 by C. M. and G. M. Hoover. The gentlemen renovated it and modernized the machinery. The employees prided themselves on preventing accidents in the factory. The company was still in operation after the death of the Hoovers. (Courtesy of Davidson County Historical Museum.)

PAINTER. Armed with only a paintbrush and a bucket of paint, this Lexington worker looked as though he had a tremendous amount of painting to get done before this job was finished. (Courtesy of Davidson County Historical Museum.)

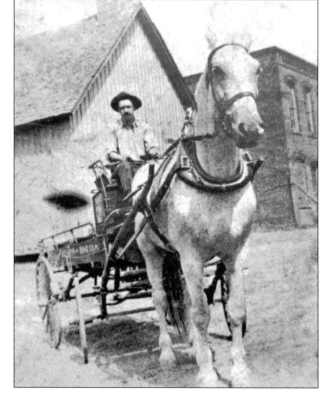

FIREHORSE. Thad Lanning is seen around 1912 with his white horse and wagon, which replaced the hand reel seen on page 92. The horses trained every day and had a certain route they would follow so they would end at the same place. When a real fire needed to be extinguished, the horse would balk when it ran past its usual place to stop during training. (Courtesy of Merle and Jerry Hodges.)

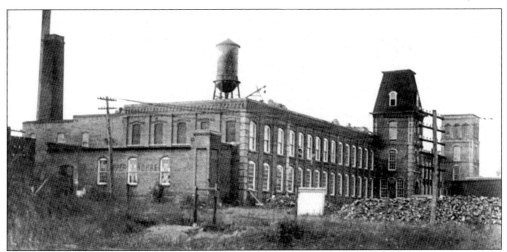

WENNONAH COTTON MILL. Established in 1886 and pictured between 1886 and 1888, this Lexington manufacturing company was named by Mrs. W. E. Holt Sr. after an Indian maiden described in the *Song of Hiawatha*. The mill employed its largest amount of people in 1900, with 250 employees. (Courtesy of Davidson County Historical Museum.)

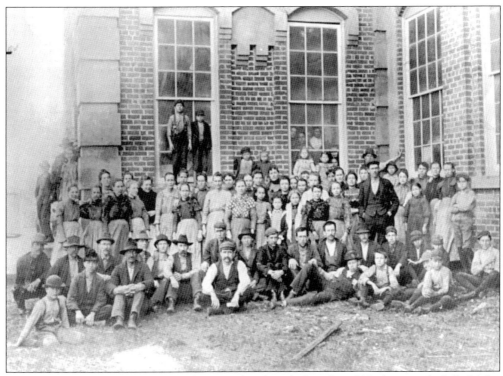

WORKERS AT MILL. Two of the workers can be identified in this 1897 photograph. Lilly Maley is in the center; Walter Jenkins, who was only 14, sits fourth from the right in the second row. Jenkins started at the mill on August 19, 1895, and ended his employment August 19, 1959. The workers in 1889 worked 12 hours a day, six days a week, at a weekly wage of $5.94. (Courtesy of Merle and Jerry Hodges.)

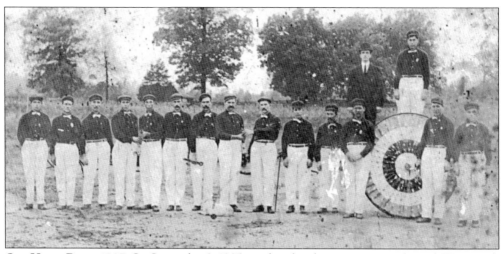

OLD HAND REEL, 1907. On September 2, 1905, two hand-reel companies were formed. Wennonah had its own fire company and eventually had a water tower to feed a sprinkler system. The hand reel was replaced by a horse and wagon in September 1912. Reel Company No. 2 is, from left to right, (first row) Edward Hayes, Sol Godfrey, Jake Palmer, C. B. Yates, Charles Pfifer, Charles Coggins, George Milsap, Earnest Taylor, Ed Hoskin, Will Link, Lindsay Link, D. C. Hayes, O. C. Kinney, and Lindo Haridster; (second row) Chief Jay Frank Spruill, and J. W. Broadway. (Courtesy of Merle and Jerry Hodges.)

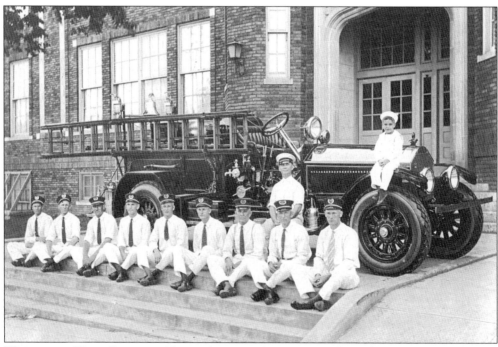

WENNONAH HOSE COMPANY NO. 2. American LaFrance trucks replaced the horse in April 1922. Pictured are, from left to right, (first row) J. C. Yarbrough; H. F. Yarbrough; D. C. Cope; H. C. Gibson; Riley Cope; Howard Michael; Ray Hill; O. B. Yarbrough; and J. L. McCarn; (second row) Dr. A. E. Brannock, chief; and Frankie Brannock, mascot. (Courtesy of Merle and Jerry Hodges.)

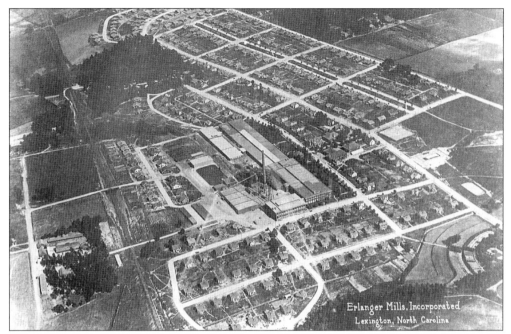

AERIAL VIEW OF ERLANGER MILLS, 1940. The buildings and the surrounding village can be seen in this aerial view of the mill. Charles and Sidney Erlanger of Baltimore, Maryland, owned and operated the mill. The Erlangers built a community surrounding the mill complete with houses, schools, a dairy, a community church, a club, and a company store. (Courtesy of Davidson County Historical Museum.)

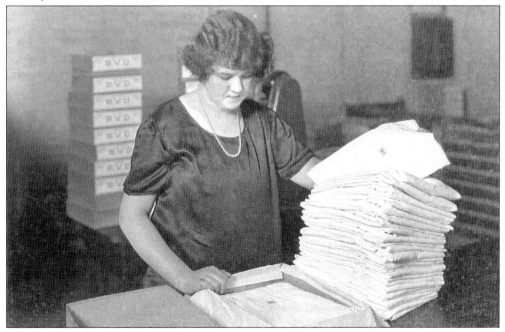

WORKING HARD. Boxes are piled high behind this woman, who packed T-shirts in boxes. She must have been aware that she was to be photographed, because she is seen doing her work in pearls and a nice dress. (Courtesy of Davidson County Historical Museum.)

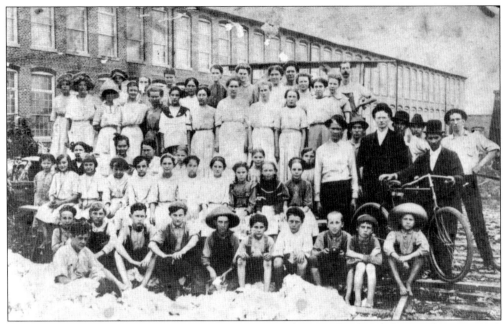

GROUP PHOTOGRAPH. Nokomis Cotton Mill was located on North Church Street. The company's officers were C. A. Hunt Sr., president; C. M. Thompson, vice president; and D. H. Hinkle, secretary and treasurer. The mill was located near the Southern Railroad tracks. The group of workers shown here included children, who can be seen in the first two rows. (Courtesy of Edward C. Smith Civic Center.)

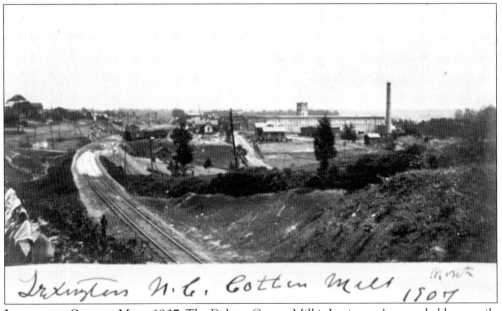

LEXINGTON COTTON MILL, 1907. The Dakota Cotton Mill is Lexington's second oldest textile industry. It can be seen in the distance down the railroad tracks. In 1910, it was one of the major industries in Lexington. The company manufactured drills, cotton bags, and sheetings. Their products were sold to a national market through J. M. Valentine Company in New York City. (Courtesy of S. C. View.)

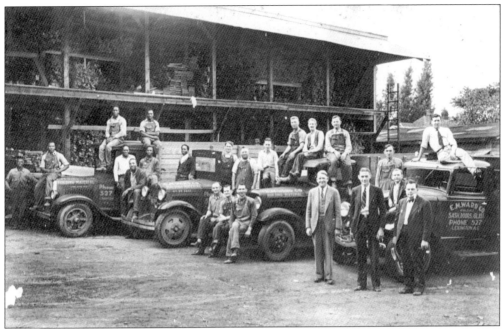

E. M. WARD COMPANY. The Ward Company is known as Hedgecock Builders. The gentlemen that have been identified by Mr. Ward are Thad Hedrick, Guy Thomas, Cliff Burkhart, Cary Ward, Garland Burkhart, Raymond Ward, Lindsay Cutting, and Kits Burkhart, all on the far right side of the photograph. (Courtesy of Katherine Skipper.)

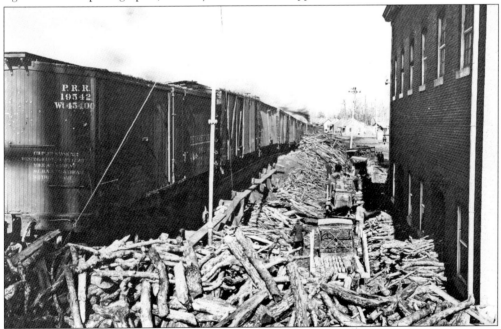

WOOD SHIPMENT. The lumber is piled high beside this train. It may have been coming into town to make furniture or to burn in the furnaces during the coal strike in 1918, when the black employees kept the plants running by making sure the furnaces were stoked with wood. (Courtesy of Davidson County Historical Museum.)

HEGE-HARMAN BUILDING DIRECTORY

1.
2. RETAIL MERCHANTS ASS'N.
3. Dr. F.C. BOSHART
4. Osteopathic Physician
4. Dr. PATTERSON
5. Optometrist
6. P. W. A.
7. Dr. FEEZOR
8. Dentist
9. HOME DEMONSTRATION-ASS
10. HOME DEMONSTRATION-ASS
11. H.H. KOONTS
12. Justice of the Peace - Notary Public
13. COUNTY AGENT
14. COUNTY AGENT
15. Co. AGT.
16. I. pc
17.
18.
19. DURHAM LIFE INSURANCE CO
20. CO. AGT.
21.
22. GRANADA THEATRE

HEGE-HARMAN BUILDING. This late 1930s–early 1940s directory shows the occupants of the building at the time. Other prior merchants in the building included Polly's Beauty Salon, Davidson Finance Company, Dr. J. Andrew Physician, and an amusement company. Today this building is the home of the Army Navy, along with other merchants. (Courtesy of Jim Nance.)

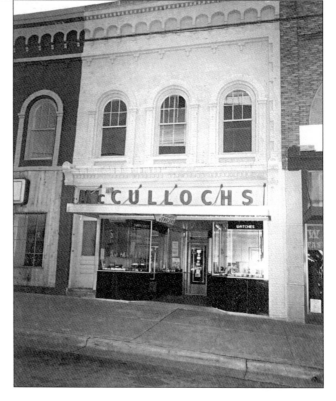

McCULLOCH JEWELERS. In the 1880s, brick machines were brought to Lexington, and several of the city's stores were redone. This building is an example of some of the earliest structures in downtown. (Courtesy of Jimmie Jean Hunt.)

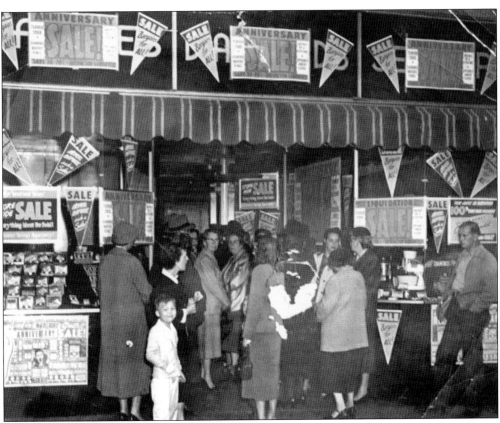

McCullochs. The jewelry store celebrates its 75th anniversary by having a sale. Anxious patrons line up outside waiting for the store to open. (Courtesy of Jimmie Jean Hunt.)

McCULLOCHS'
JEWELERS

N⁰ 2949

Lexington, N. C., *June 21* 193*7*

Received of *Willie Everhart*

One Dollars and *X* Cents

McCULLOCHS', Inc.

Per *D. F. McC*

$ *1.00*

(✓) **On Account**
() **Deposit on Mdse.**
()

To be credited on the entire account
This is the only form of receipt recognized by this company.

Receipt. This customer of McCullochs would come in once a week and pay $1 towards the amount of money he owed on his account in 1937. (Courtesy of Jimmie Jean Hunt.)

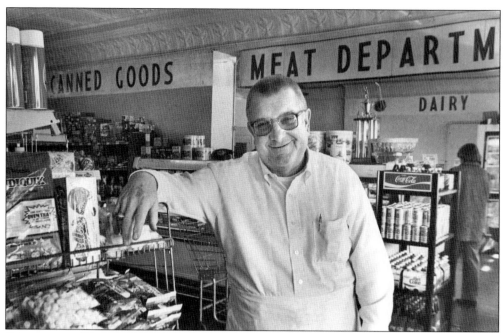

CONRAD AND HINKLE. Opened in 1919, this store is still in the same location as when it began. In 1934, Hinkle bought out Conrad. In 1940, the market offered their customers a home delivery service and the opportunity to purchase processed meat directly from the store. (Courtesy of Davidson County Historical Museum.)

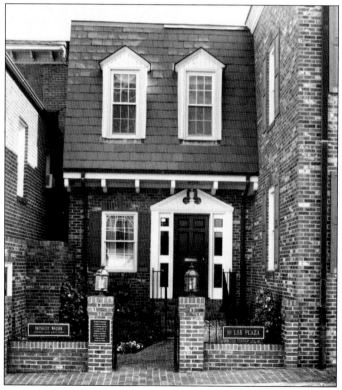

BRINKLEY WALSER, PLLC. This law firm is the oldest firm in Lexington. According to Walter Brinkley, "The firm had its beginning on October 4, 1886, when Zeb Vance Walser of Davidson County was admitted to the Bar of North Carolina and began to practice law in Lexington. Since that time, this practice has been continued by him, his partners and successors without interruption." Today a portrait of Don A. Walser, Zeb's son and a member of the firm during his lifetime, hangs in the library above the fireplace. Walter F. Brinkley is currently the firm's senior partner. (Photograph by Bo Bennett.)

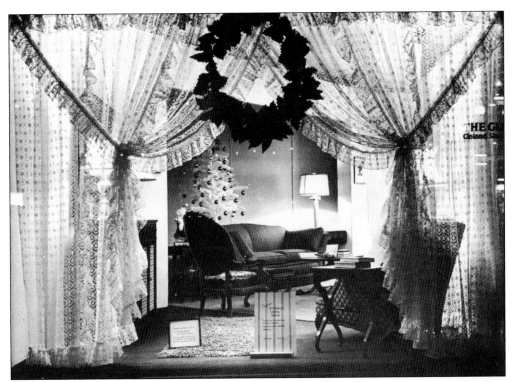

BELK WINDOW. This Christmas window display shows a living room set of 18th-century furniture. The living room set shown is a replication of furniture during a very elegant and stylish period.

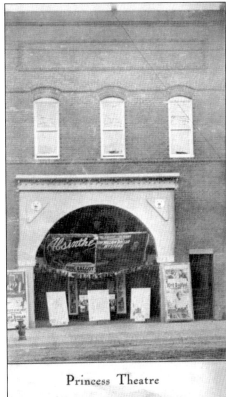

Princess Theatre

PRINCESS THEATER. The Princess Theater, owned and managed by F. C. Carroll, was built in an astonishing 45 days. Carroll opened his first theater in Chicago, Illinois, in July 1897. The Princess seated 372 patrons and offered a six-piece orchestra and the best picture theater in the state. The interior boasted beautiful tapestry, panels, a ceiling of cream, and side walls of old rose. (Courtesy of the Davidson County Library.)

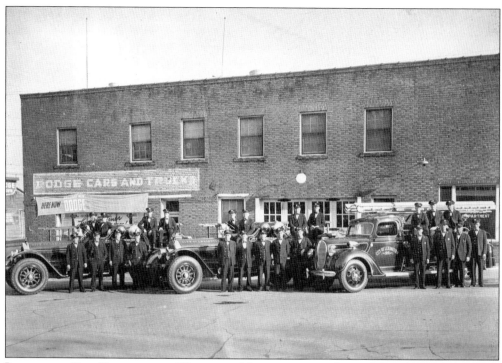

LEXINGTON FIRE DEPARTMENT. These proud firemen pose in front of their brand-new trucks. These trucks replaced the horses in 1922. (Courtesy of Davidson County Historical Museum.)

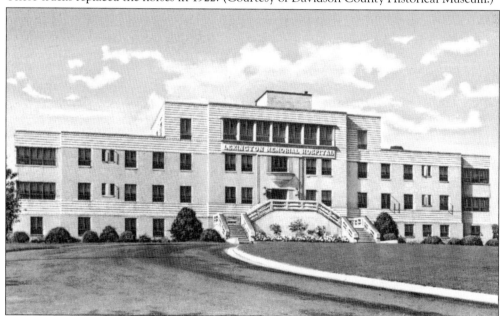

LEXINGTON MEMORIAL HOSPITAL. This hospital is a nonprofit hospital. The hospital is located on Hospital Drive and today has 85 acute care beds and medical doctors skilled in more than 20 specialties. In the early days, if someone was sick, a quarantine poster would be posted on the house with what ailed them, be it measles, mumps, whooping cough, or chicken pox, so the town would know to stay away. (Courtesy of Davidson County Historical Museum.)

Nine

FUN AND CELEBRATIONS

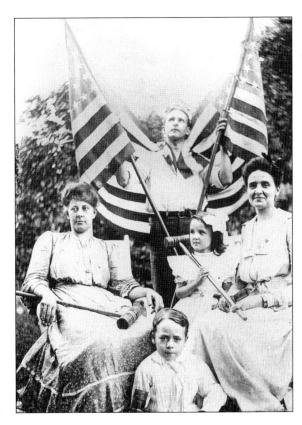

PATRIOTIC LEXINGTON. In a photograph taken in the early 20th century, this family is very patriotic. Surely picnics, parades, and ice cream await the family. (Courtesy of Davidson County Historical Museum.)

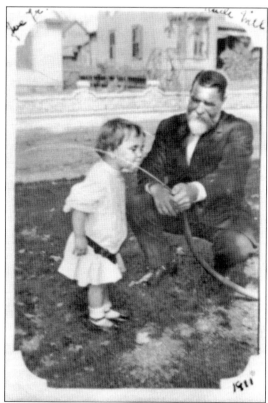

EATING WATERMELON. Minnie Rhoades and Pearl Leonard are eating watermelon slices in a field on a nice summer's day in the 1920s. (Courtesy of Davidson County Historical Museum.)

JOE MOFFITT SR. AND JOE MOFFITT JR., 1911. Little Joe gets a refreshing drink from his dad courtesy of the garden hose. (Courtesy of Merle and Jerry Hodges.)

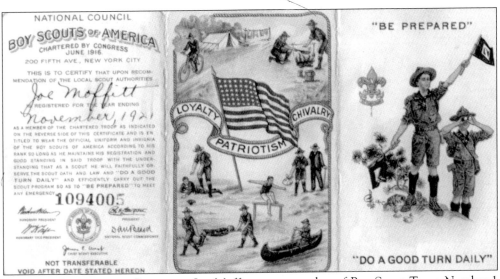

LOYALTY, PATRIOTISM, CHIVALRY. Joe Moffitt was a member of Boy Scout Troop Number 1 in 1921. He has learned the Boy Scouts of America was incorporated on February 8, 1910, in Washington, D.C. This date is recognized as the birthday of American Scouting.

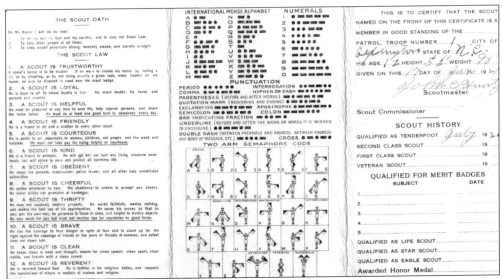

BOY SCOUT CARD. In 1909, William D. Boyce, an American publisher from Chicago, was traveling in London. Not being familiar with the city and being in the midst of thick fog, a boy asked him if he could help him find his destination. Upon their arrival, Boyce tried to tip the boy, who politely refused, stating, "No, thank you, sir. Not for doing a good turn." "And why not?" asked Boyce. "Because I am a Scout. And a Scout doesn't take anything for helping." (Courtesy of Merle and Jerry Hodges.)

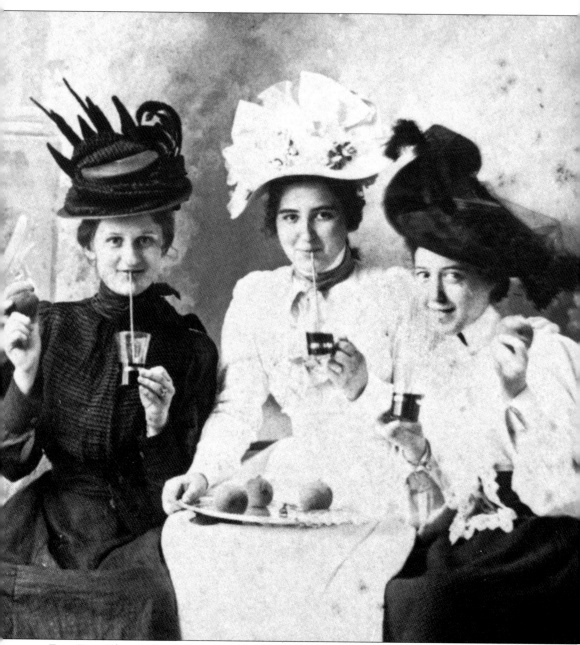

FUN DAY. These ladies look as though they are having a fun time out on the town for the day. How about those fantastic hats! Shown here are Mrs. Occo Pickett, Mrs. A. A. Springs, and Mrs. Sam Finch, in the late 19th century. (Courtesy of the Edward C. Smith Civic Center.)

ANNIE OAKLEY SADDLE. From 1885 to 1902, Annie Oakley was part of Buffalo Bill's Wild West Show. Her amazing feats of marksmanship were her trademark. In 1901, as the show was traveling through Lexington, her train crashed near Southmont, and unfortunately she was partially paralyzed. Even so, she was still a "dead shot" and continued her performances. Her saddle can be seen at the Davidson County Historical Museum. (Courtesy of Davidson County Historical Museum.)

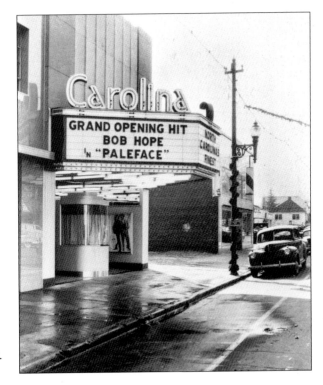

CAROLINA THEATER. The theater opened on a Monday evening, December 13, 1948, replacing the roadhouse that caught fire and burned in 1945. Bob Hope's comedy *Pale-Face* was an excellent movie choice, as his comedies were an all-time favorite for many people. (Courtesy of the Edward C. Smith Civic Center.)

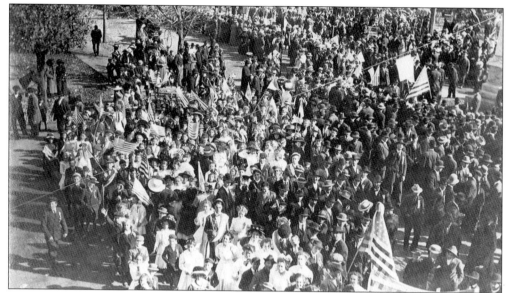

CROWDED DAY AT THE PARADE. Everyone loves a parade, especially when it was in celebration of the end of a war. (Courtesy of Davidson County Historical Museum.)

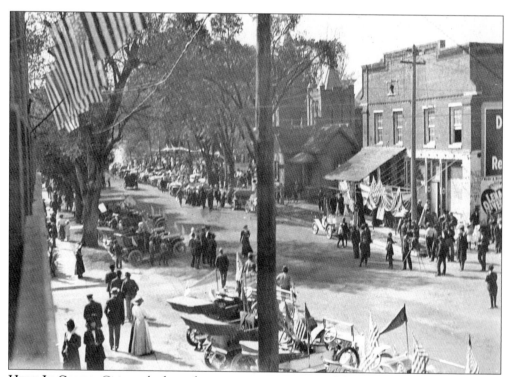

HERE IT COMES. Citizens look up the street in anticipation of the floats and marching bands soon to pass their way. A photographer has his camera set up in the middle of the street. All the cars parked on the side of the road are adorned with flags. (Courtesy of Davidson County Historical Museum.)

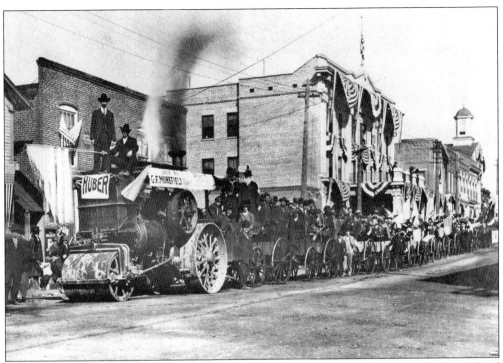

HUBER STEAM ROLLER. Huber's float leads this parade. There are dozens of carriages lined up behind him waiting to start down the street. (Courtesy of Davidson County Historical Museum.)

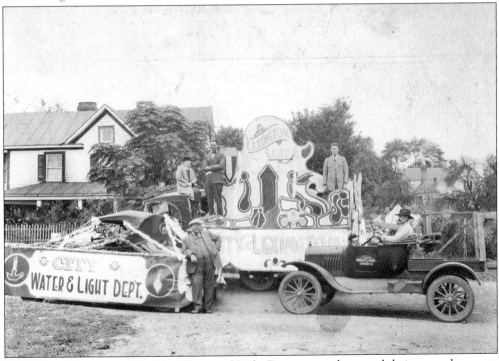

LEXINGTON PARADE, 1913. The Water and Light Department decorated their car and a wagon to make this impressive float. (Courtesy of Davidson County Historical Museum.)

FRITTS FAMILY. The relatives gathered on the Fritts Farm for a day of food and fun. The patriarch of the family, Mack Fritts, is sitting down in the chair with his children behind him in order from the oldest on the left to the youngest on the right; they are Hugh, Henry, Jeff, Elsie Trogdon, Ernest, Della, and James. The boy in the foreground is Don Fritts.

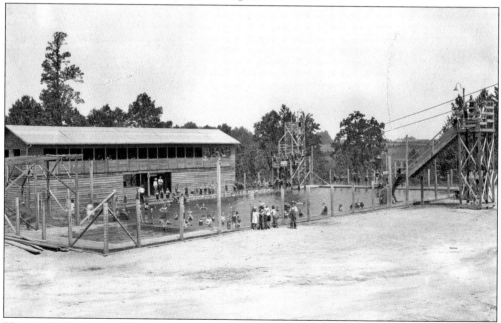

HOLTON'S SWIMMING POOL. Located off Lindwood Road, the pool was a nice treat for many during hot summer days. People came from all over to relax and enjoy the water. (Courtesy of Davidson County Historical Museum.)

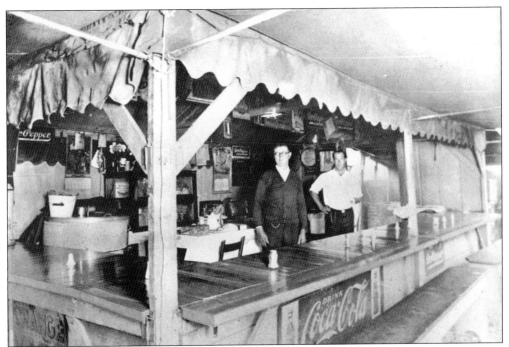

SID WEAVER'S HOT BARBEQUE. Sid Weaver's Hot Barbeque was made fresh daily. It was located on Center Street, about where courthouse is now. (Courtesy of Davidson County Historical Museum.)

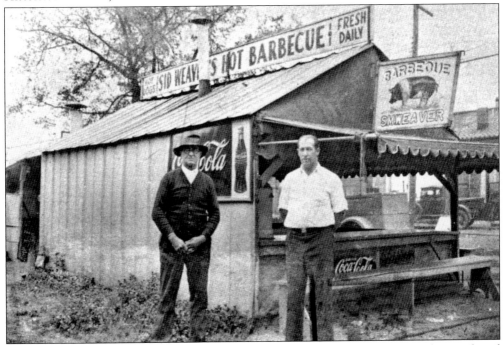

SID WEAVER'S HOT BARBEQUE. Sid's Barbeque was one of the barbeque pits that perfected cooking pork shoulders over hot wood coals, giving Lexington its name as "The Barbeque Capital of the World." (Courtesy of Katherine Skipper.)

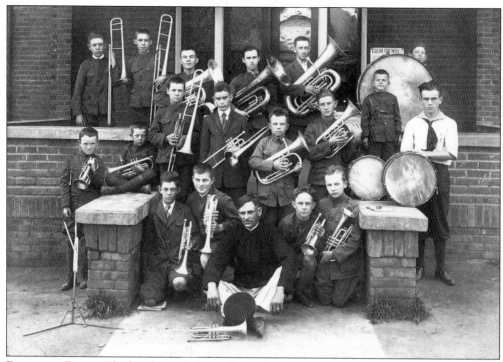

ERLANGER BAND. The band traveled to different locations and played for colleges and at other functions. (Courtesy of Davidson County Historical Museum.)

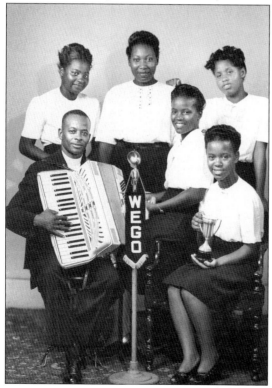

WEGO SINGERS. The apparent winners of a contest in the 1950s, this musical group proudly posed with their trophy at the WEGO radio station. (Courtesy of Davidson County Historical Museum.)

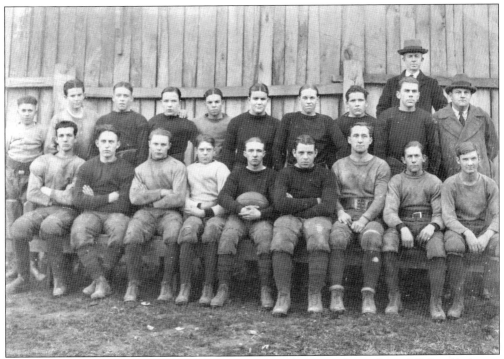

LEXINGTON FOOTBALL TEAM, 1920. These boys were brave to play without full-faced helmets. Hopefully they had good dental plans! (Courtesy of Davidson County Historical Museum.)

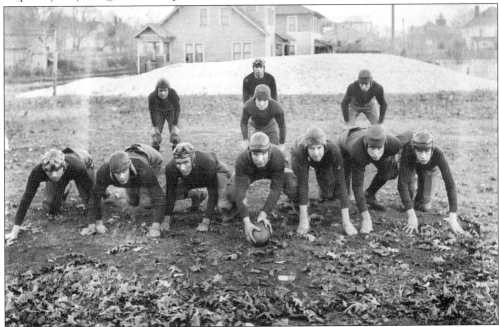

FOOTBALL TEAM 1922. Pictured from left to right are (first row) Chalmer Hutchens, Robert Lefevre, Curry Lopp, Buck Anderson, Moton Leonard, Tom Eanes, and Oliver Peacock; (second row) Gene Young, Bruce Conrad, Lloyd Everhart, and Doc Leonard. (Courtesy of Davidson County Historical Museum.)

FIELD HOCKEY TEAM, 1930. Field hockey is one of the oldest of competitive pastimes. Originally this sport was considered too dangerous for female participation. It quickly became popular to women who played croquet and lawn tennis. Eventually it was considered the only team sport proper for women. In 1901, the sport was introduced in the United States. (Courtesy of Davidson County Historical Museum.)

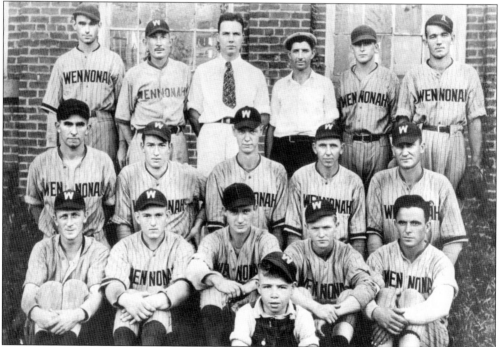

WENNONAH INDIANS, 1934. The Wennonah baseball team became part of the Carolina League, and local fans came to root them on. Max Lanier came to pitch for the team in the afternoons and received $5 a game. Shown here are "Boob" Kimbrell, mascot, in front; (first row) Lacy Robbins, Gatchell Cox, J. D. Holt, Rocky Johnson, and Roby Biesicker, (second row) Mal Craver, Homer Lee Cox, Link, Russell Craver, and Yarborough; (third row) Tate, unidentified, Moffitt (scorekeeper), (chief rooter), Willie Kimbrell (manager), Charles, Biesecker, and unidentified. (Courtesy of Davidson County Historical Museum.)

LET'S MEET AT BATTLEGROUND. This cute Valentine postcard entices the Lexington recipient to meet her boyfriend in Greensboro for a Valentine date. (Courtesy of Davidson County Historical Museum.)

WELL, HARDLY. "Our town slow? Well, I guess not; What are you a-drivin' at? Don't you know A man got shot For sayin' such a thing as that? Walter Juan Davis." The sender of this 1909 postcard certainly let the person receiving the card know Lexington surely is not a slow-paced town. (Courtesy of Davidson County Historical Museum.)

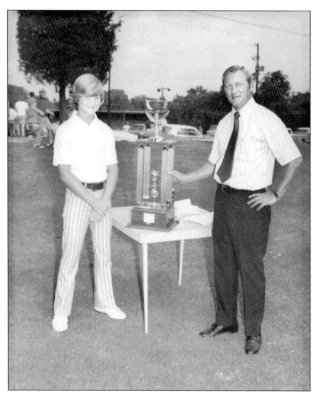

STEVE COLES. The Lexington City Junior Championship is held once a year. Steve Coles is seen being awarded a trophy by Bill Cook in the early 1970s. The tournament was held in honor of his father, Dusty Cook, who was the police chief of Lexington for many years. (Courtesy of Steve Coles.)

GAITHER WALSER. Golfing is a favorite pastime for many Lexington residents. The Lexington Golf Course was built in 1938 for the city of Lexington. Even though it is called "the country club," it has been a municipal golf course for as long as it has been open. In November 2003, the course closed for almost a year for major renovations. The course won a national award following the completion of the work. (Courtesy of Vance and Joy Walser.)

Ten

CHURCHES AND CEMETERIES

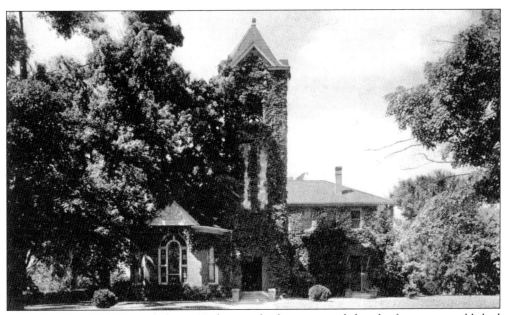

FIRST PRESBYTERIAN. Founded in 1827, this was the first organized church of any type established in Lexington. In 1840, the First Presbyterian Church was built at the corner of South Main and West Third Avenue. Certain sections of the church are more than 150 years old. Sometime during the 1940s or 1950s, some of the men were concerned the ivy that covered the tower may damage the mortar, so one night, one of the men cut it at the base of the tower, believing it would wither and die. The women of the church caught wind of the plan and were terribly displeased by all this talk. Realizing how upset the women had become, the gentleman who had cut the ivy quietly returned at night and taped the severed ivy back to the roots so none would be the wiser. (Courtesy of Davidson County Historical Museum.)

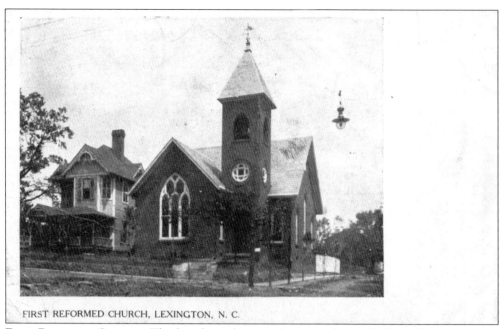

FIRST REFORMED CHURCH, LEXINGTON, N. C.

FIRST REFORMED CHURCH. The founder and pastor of the church was Dr. Jacob Calvin Leonard. He laid the cornerstone for the church on October 4, 1900. Dr. Leonard led the church until his death in 1940. (Courtesy of S. C. View.)

CERTIFICATE OF BAPTISM, 1910. Julia Elizabeth Parks was baptized when she was six years old by Rev. J. C. Leonard at the First Reformed Church. (Courtesy of Katherine Skipper.)

WHEN THIS FELLOW was two and a half years old, about the time this picture was made, he gave his first public speech at the First Reformed Church Christmas service in Lexington. His recitation:

"My mamma said, 'If you are good,
My dear, till Christmas day,
Old Santa Cláus will bring to you
A dollie and a sleigh,
A pair of roller skates, a book,
A table and some chairs,
A bureau and a writing desk,
A large doll's house with stairs,
In fact, he'll be real kind to you,
If you are only good and true.'

Well Christmas came, and I declare,
I never really felt so sad,
For though I hunted everywhere,
One little doll was all I had."

In case you don't recognize the picture, he's Dr. Jake Leonard.

CHRISTMAS POEM. Jake Leonard, at the tender age of two-and-a-half, recited a poem for the congregation at the First Reformed Church. (Courtesy of Katherine Skipper.)

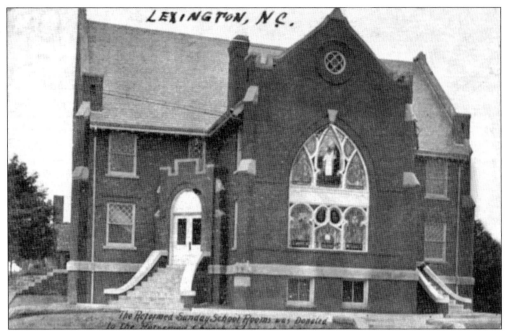

REFORMED CHURCH SUNDAY SCHOOL BUILDING. In 1911, the membership of the church was steadily growing, and the need for a Sunday school building was realized. In 1912, the cornerstone was laid with various articles enclosed inside it, including a Bible. The building was presented to the Reformed Church by J. T. Hedrick of Lexington. (Courtesy of Katherine Skipper.)

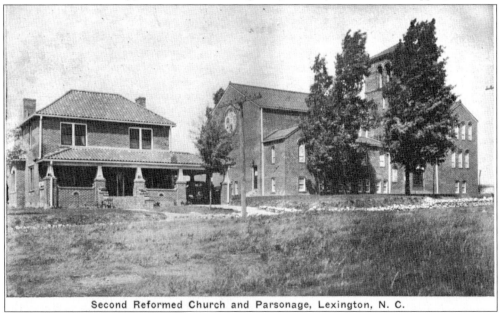

Second Reformed Church and Parsonage, Lexington, N. C.

SECOND REFORMED CHURCH AND PARSONAGE. On October 11, 1903, a lot was offered by the Nokomis Cotton Mill to build this church. Dr. Leonard was concerned for the spiritual needs of the people in the outlying neighborhoods. The lot was located on the corner of Raleigh Road and North Church Street. The church began on March 13, 1904, with 22 members. (Courtesy of Davidson County Historical Museum.)

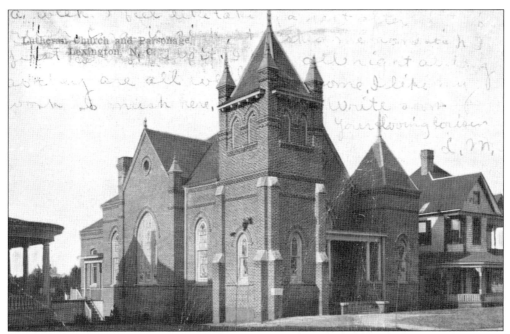

FIRST LUTHERAN CHURCH AND PARSONAGE. The Lutheran congregation was formed in 1905 and gathered at Hedrick Hall for their Sunday service. Their church was formally opened on January 13, 1907, with Pastor Edward Fulen Wider at the helm. This church was demolished in 1957 to build a more spacious church to make room for the growing congregation. (Courtesy of Davidson County Historical Museum.)

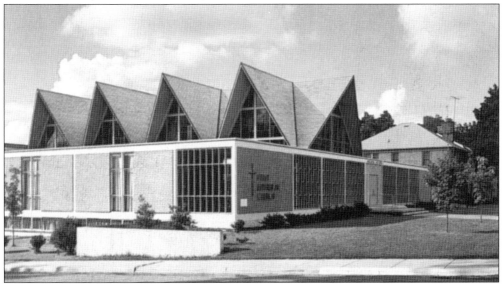

LUTHERAN CHURCH AND PARSONAGE. From 1957 to 1959, during the construction of the new church, the congregation met at the Pickett School. A new parsonage had previously been built in 1940 and serves today as the Lutheran Youth House. C. Ross Ritchie served the church from June 1939 to August 1942, when he left to serve in the army. He returned in February 1946 and stayed until 1950. Today Pastor Derick Boggs leads the congregation in service. (Courtesy of Davidson County Historical Museum.)

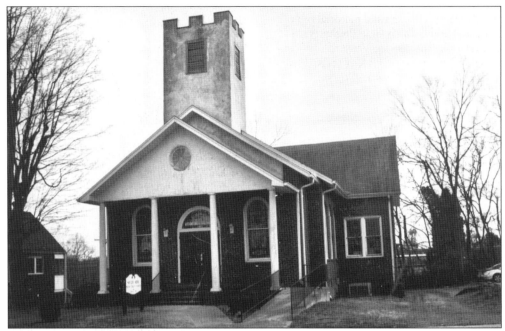

SHADY SIDE PRESBYTERIAN CHURCH, C. 1867. Shady Side is truly a shining light in the Lexington community. This church is the first black Presbyterian church in Lexington, North Carolina. The church came about from the dedication and devotion of Rev. James Chestfield. Today the church is led by Rev. Milton Crump. (Photograph by Bo Bennett.)

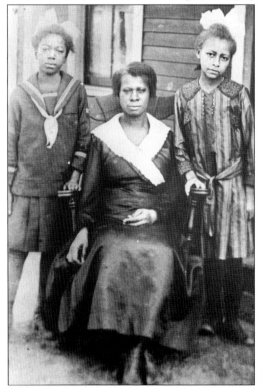

SUNDAY. Gertrude Mabry is on the left posing with her grandmother, Bertha Powell, and her cousin, Ida Mabry, before attending Shady Side Presbyterian Church services. Mrs. Powell worked in the March Hotel as a cook. Gertrude and Ida attended Federal University and became schoolteachers at Dunbar School. (Courtesy of Davidson County Historical Museum and Gertrude Mabry.)

BIBLE, 1900. This original pictorial bible is located at the Shady Side Presbyterian Church. The King James Version (KJV) of the Bible was the standard Bible from 1611 until about 1900. (Photograph by Bo Bennett.)

BIBLE, 1900. Mrs. Nora presented this Bible to the church in November 1900. The pages are brittle, but the Bible remains intact to this day. (Photograph by Bo Bennett.)

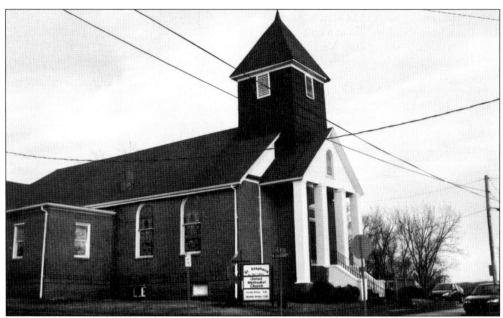

ST. STEPHENS CHURCH. In 1868, a small group met on Old Greensboro Road near the home of Hamp Oliver to worship. They named their church the King Methodist Church. The church was later renamed St. Stephens Methodist Episcopal Church. Today Rev. Paul Milton leads the congregation in their Sunday worship. (Photograph by Bo Bennett.)

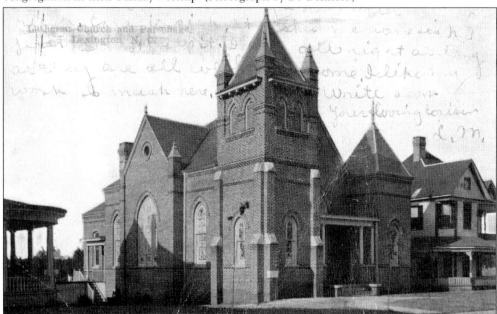

FIRST BAPTIST. In the early days, the Baptists and the Lutherans took turns meeting upstairs in the old courthouse, switching every other month. On July 31, 1881, the Baptist Church was formally organized. In 1883, a lot was purchased for $200 on South Main Street. The church was active until 1955, when it was torn down and replaced with a new church. The original stained-glass windows were kept and used in the new building. (Courtesy of Davidson County Historical Museum.)

FIRST METHODIST EPISCOPAL CHURCH.
This church was built in 1874 at a cost of
$5,000 and is located on South Main Street.
Unfortunately the building burned down
August 7, 1902, and it was one of Lexington's
worst fires. In April 1903, the cornerstone
was laid and people worshiped at this site
until the services began in May 1955 in the
building that still stands today. (Courtesy of
Davidson County Historical Museum.)

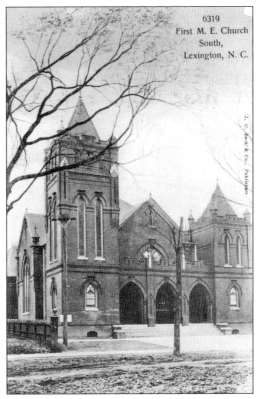

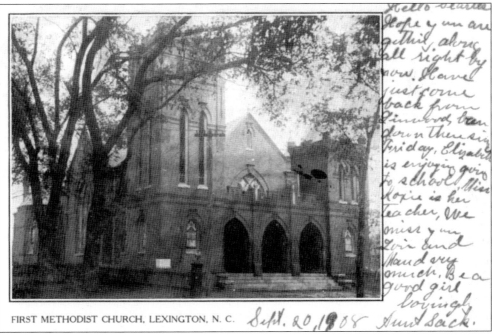

FIRST METHODIST CHURCH, LEXINGTON, N. C. Sept. 20, 1908 Aunt Sack.

FIRST METHODIST CHURCH. It is said that the first sermon Lexingtonians heard came from a
traveling preacher. Watson and Cecil supplied bricks to rebuild the tower and spire of this church
in the early 1890s. (Courtesy of Davidson County Historical Museum.)

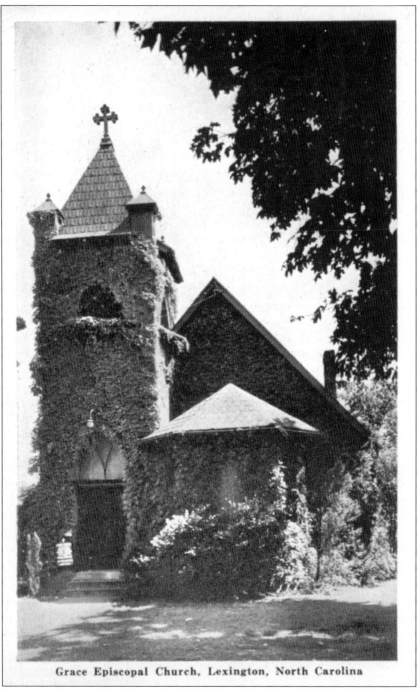

Grace Episcopal Church, Lexington, North Carolina

GRACE EPISCOPAL. Some of the first Episcopal families in Lexington included the Holts, Caldceughs, Longs, and the Lindsays. The first part of the church stood in the vicinity of Wennonah Cotton Mill and was blown apart by a windstorm and never rebuilt. In 1900, the church was reorganized and built anew in a Gothic Revival style; it is now located on Main Street across from the Homestead. A stained-glass window in the church is dedicated to W. E. Holt Sr., who resided at the Homestead. (Courtesy of S. C. View.)

LEXINGTON CITY CEMETERY. The cemetery was started in 1743 and was used for burying slaves. An engraved rock was placed in the graveyard in their memory, but the writing became worn. The rock was replaced with a granite plaque that stands on top of the original rock monument erected in their honor. Since the 18th century, many families have found their final resting place in the Lexington cemetery. A plaque at the entrance reads "bury West to East to Face the Rising Sun on resurrection morn." (Photograph by Bo Bennett.)

ELIZABETH O'DANIEL, CONSORT OF F. A. MYERS. The flowers on a gravestone represent earthly existence of brevity. A consort is a wife or a companion who habitually associates with a particular person. It is not known whether O'Daniel was the wife or companion of Myers. She lived a mere 38 years. Either way, he cared enough to purchase this headstone for her. (Photograph by Bo Bennett.)

IVY. Christian symbolists consider the ivy's need to cling to a support a symbol of a delicate people in need of heavenly support. Like other evergreens, the ivy symbolizes eternal life and resurrection. Medieval Christians, noticing that ivy thrived on dead trees, used it to symbolize the immortal soul. (Photograph by Bo Bennett.)

MARY FRANCIS MARCH. The following is engraved on this tombstone: "Daughter of S. L. and L. R. Williams August 16, 1894–Oct 20, 1918; Master though mayst keep my gem safe in the house not made with hands. Tis Thine and Mine. Mother." The angel symbolizes rebirth, resurrection, and protection on the journey from earth to heaven. (Photograph by Bo Bennett.)

BIBLIOGRAPHY

DeLapp, Simm A. *People, Politics, Religion*. Raleigh: Sim A. DeLapp, 1975.

Fick, Virginia G. *Country College on the Yadkin, A Historical Narrative*. Winston-Salem: Hunter Publishing, 1984.

Genealogical Society of Davidson County

Howell, Rev. Ray, and Davidson County Historical Museum. *Davidson County*. Charleston, SC: Arcadia Publishing, 2000.

http://education.yahoo.com/reference/encyclopedia/entry/Wrightbro

http://www.accessgenealogy.com/native/tribes/saponihist.htm

http://www.angelfire.com/realm/shades/nativeamericans/occaneechi.htm

http://arcims.webgis.net/nc/davidson/default.asp

http://www.bartleby.com

http://www.boeing.com/history/boeing/war.html

http://www.co.davidson.nc.us/Museum/

http://www.elook.org/city/cities/Lexington_NorthCarolina.html

http://www.geocities.com/mahenip/

http://www.ah.dcr.state.nc.us/

http://www.occaneechi-saponi.org/

http://www.osv.org/learning/DocumentViewer.php?DocID=2072

http://www.pagstones.com/pgs_bloom_hrt_vase_sym.page.html

http://politicalgraveyard.com/bio/headden-healey.html#RS90H8WQF

http://www.saponitown.com/

http://www.thepeerage.com/p11950.htm

Leonard, Rev. Jacob Calvin. *Centennial History of Davidson County, North Carolina*. Raleigh: Edwards and Broughton Company, 1927.

Lexington, North Carolina pamphlet, 1914.

Matthews, Mary Green, and M. Jewell Sink. *Pathfinders Past and Present: A History of Davidson County, North Carolina*. High Point, NC: Hall Printing Company, 1972.

Skipper, Katherine F. *A Celebration 1901–2001: 100 Years in the Life of the First Reformed Church of Christ Lexington, North Carolina*, Lexington: Davidson Printing, 2001.

Trailblazer Magazine Teachers Guide. "U.S. Women In History." March 2001.

Touart, Paul Baker. *Building the Back Country: An Architectural History of Davidson County, North Carolina*. Lexington: The Davidson County Historical Association, 1987.

Walser, Richard. *Five Walsers*. Raleigh: Wolf's Head Press, 1976.